# THE GOLDEN LIBRARY

*NO. 8*

## AN ACCOUNT
## OF FRENCH PAINTING

*

*Other books on Art*
*By the same Author*

\*

ENJOYING PICTURES
ART: A CRITICAL ESSAY
POT-BOILERS
SINCE CÉZANNE
LANDMARKS IN
NINETEENTH CENTURY PAINTING

\*

*Chatto & Windus*

# AN ACCOUNT OF FRENCH PAINTING

*By*

Clive Bell

LONDON

CHATTO & WINDUS

1936

FIRST IMPRESSION : NOVEMBER 1931
SECOND IMPRESSION : JANUARY 1932
FIRST ISSUED IN THE GOLDEN
LIBRARY : APRIL 1936

*To*
*Georges Duthuit*

# FOREWORD

An eminent critic told a friend of mine that all he knew of French he had learnt from reading my books. I am impenitent. I want to express myself; and if I can put across a shade of meaning, convey a mental reservation, render the elevation of an eyebrow or the shrug of a shoulder by dropping into French, by using slang, or even by a pair of dashes, I shall not hesitate to do so. The only remonstrance that could touch me at all would be that of some genuine student who complained that he could not catch my meaning because he could not understand my language. No such student exists.

Clive Bell

CASSIS.   JUNE, 1931.

# CONTENTS

# ILLUSTRATIONS

# ILLUSTRATIONS

# An Account
# of French Painting

## PRIMITIVE

Fʀᴏᴍ the first I would warn anyone who happens to pick it up that this is no more than an essay. In forty thousand words or so one cannot write a full-dress history of French painting. But when it became known that the National Art Collections Fund hoped to arrange an exhibition in the spring of 1932, I, obliged, if not precisely " by hunger and request of friends " yet by external pressure, agreed to say something about it. And as I have neither the talent nor the industry for historiography on the grand scale—my turn being rather for

cutting a long story short—it seemed best to try to make out of my small knowledge and perhaps superabundant ideas a little book to be read with profit, I hope, and certainly without tears. It should be none the worse, and certainly I shall enjoy writing it none the less, because the notion of writing was put into my head by friends, some of whom were good enough to say that they would like to have me for guide to the exhibition ; and if I am vain enough to believe that it has merits beyond those of Baedeker, I can excuse myself in the reflection that a little vanity in an author will never come amiss so long as the vanity of authors is an unfailing provocation to wit in those who most need it.

The first problem that confronts me, and the worst, I hope, is where to begin. In those lands which now compose the territory of the French republic, one and indivisible, painting there has been since the days of the cave-men. Should I lead off then with a few scholarly pages on the discoveries at La Mouthe and the Cro-Magnon movement ? Perhaps it would be as sensible as

to start where many historians have started, that is with the mysterious school which is thought to have flourished at Rheims early in the eleventh century, which by some is held to have been English, by others German, and about which no one seems to know anything for certain. And why, if geographical position is to be the test, stop at Rheims and ten hundred on one's journey backwards ? Almost a thousand years earlier artists and artisans were at work in the Roman province of Gaul, and after them came a more gifted race to produce, in the same area, work which to my seeing is no more French than what was being produced simultaneously in Germany, Flanders and the north of Spain. Merovingian and Carolingian is just provincial art in the Romano-Byzantine manner ; and a writer on French painting should not be expected to say anything about it. In my opinion he should not be allowed to speak of " French " art till the turn of the millennium at earliest ; and even then how much justification can be found for insisting on the patriotic epithet ?

It is not till the dawn of the twelfth century that we come on painting which, by the exercise of some ingenuity, can be made out to have something specifically French about it. With Saint-Savin (about 1100) begins French mural painting, and Montmorillon was decorated some hundred years later. Here certainly are noble manifestations of a new spirit expressing itself through the Byzantine tradition, and in places expressing itself in a manner perhaps just perceptibly French. Anyhow about Saint-Savin and Montmorillon I must say something presently. In the thirteenth century we have a great school of purely French painting, but it is glass-painting; and to say more than a few words about glass-painting in an essay, and what is more an *ad hoc* essay, would be out of place. Of the illuminators of the twelfth and thirteenth centuries, of the miniaturists at work during the life of Charles V (1337–1380), of the Flemish school in the north which in the east was called Burgundian, of those dashing Parisian years that lie round about 1400, of the Avignon masterpieces and the art of the

medieval decadence, something must be said : but what has to be said most often is—how far are we justified in calling these things " French " ? Remember that in the Middle Ages France had no permanent north-east frontier, and that geography, which makes idiots of us all, makes of politicians and art-critics dangerous lunatics, and then ask yourself in what sense any medieval paintings, except the windows, can be so described. The men who made them lived, for the greater part of their lives at any rate, in lands which were or were to become parts of the kingdom of France. Yes, but most of them were born without ; and one does not dream of calling Poussin Italian because he spent his working life in Rome, though he owed as much to the Italian tradition as the fourteenth century miniaturists, with their Flemish names, owed to French civilisation. Holbein and Van Dyck lived and worked in London at important moments in their lives, yet no one in his senses claims them for the British school : neither do we claim Sisley, though both his parents were English. Hamilton, who wrote

*Les Mémoires du Comte de Gramont*, was British born and bred and as thoroughly French as Sisley. On the other hand, I never heard of *The Decline and Fall* being claimed as a Swiss masterpiece though the greater part of it was written at Lausanne, and Rossetti is as much an English poet as Morris. Language settles it, you say. Very well, what is the idiom of medieval painting in France? The question remains where it was, and what are we to do about it? In the first place I think we must discover what we mean by "French."

Until we have come to some conclusion the name not only of this essay but of the exhibition is meaningless. So what is it, this mysterious quality? Apparently neither domicile nor descent suffices; yet when we speak of "a French picture" we do mean something. What is more, though in my opinion (and I shall give reasons for it) there was no such thing as a French school of painting proper before Poussin—no centre of inspiration imposing a style and a tradition —yet in the Middle Ages there certainly were such things as French pictures. What

then do we mean when we call a picture French?

When I say that, though in my opinion there was no such thing as a school of French painting proper in the Middle Ages, yet there were such things as French pictures, I mean that from time to time one sees a picture of that period which, unmistakably affiliated though it be to the Flemish or Italian school or to both, yet possesses, over and above (or should one say beneath) these foreign characteristics, a quality that forces one to exclaim—" That's French." Such a picture we shall expect to have certain qualities in common with the sculpture at Chartres and the glass at Bourges, with the architecture of Mansard and the painting of Chardin and Renoir, to say nothing of the prose of Montesquieu; and these peculiarities will doubtless prove to be the expression of something more fundamental still—something that makes us exclaim " How French! " before a shop-window in Paris or as we watch a midinette pulling on her hat. I remember sitting in the Café Royal and observing a young man who had come in alone and sat

himself down on the opposite side of the room. Evidently he was going to catch a train as soon as he had dined, for he had put his bag beside him and across his bag a rug, and on these he had so balanced a folded coat as to form a table on which to arrange with deliberate but easy neatness his hat, his stick, his novel and his gloves. With one voice my companion and I exclaimed— "He's French!" He was, we surmised, a commercial traveller, and in his easy, well-considered neatness we found a manifestation of the mysterious quality. Here is Frenchness at its lowest and most banal. Go now to the middle of the Place Vendôme, if you dare, and see it—this quality—in all its glory still joining hands with the commercial traveller. Stand before a Poussin, a Watteau, a Chardin, a Corot or a Cézanne, and you will see it—the quality—transmuted to something infinitely subtle, exquisitely delicate and fine ; but in the background, sure enough, there is the commercial traveller with his easy, neat way of dealing with facts : the divers manifestations still touch hands.

No one who generalises as much as I

has a more lively mistrust of generalisations. All this about French or English—how silly it is, seeing that there are some forty millions of us in either country and each one different from all the rest. Of my friends perhaps a third are French, and surely I must have more in common with them than with ninety-nine per cent. of my countrymen. To what then can national characteristics amount? They may not amount to much: they are real none the less. For when we say, how French he or she is, how typically French is that point of view, that play, that novel, that picture, that saying, that politician, that chauffeur, that railway station, that villa garden, that regulation, that way of tying a knot, we do mean something, we are not talking sheer nonsense. It is inconceivable that the plays of Shakespeare should have been written by a Frenchman, or the plays of Racine by anyone who was not. There is such a thing as Frenchness, and it is a thing that reveals itself in life and art. Before talking about French painting it would be as well to have some idea of what it is.

Above all races I know or ever heard of, the French love life. By life I do not mean something grandly vague which begins as a rule with a capital L, but the good things of life, thought and feeling and sensation, bread and wine, sunshine and laughter, the pride of the eye and the lusts of the flesh, " le vierge, le vivace et le bel aujour-d'hui." The most French thing about French art is its humanity : I use the word in its classical sense—*humani nihil a me alienum puto*. Not if he can help it will a French artist quite lose touch with earth. In a world of pure phantasy he is ill at ease. Also, though this may sound strange at first hearing, the French temper is not happy in a world of extremes. Mark you, I do not say that the French intellect rejects extreme opinions, but that the French temper shuns a world of extremes. Absolutes are all very well to play with, feel the French, but ill to live in. Unluckily absolutes are as dangerous to play with as fire : I have not forgotten the Revolution and a few more regrettable incidents of the sort when I say that the individual Frenchman has a taste

for moderation. To get the most out of that life he adores, he is willing to cut his ambition to the measure of his capacity. He prefers cultivating his garden intensively to exploring the poles of exaltation and despair. Also the French love this life of theirs so well that they take it seriously : the frivolity of the English would appal them could they believe in it. Take two examples. The French take eating seriously, and consequently insist on their food being eatable : a nation so incurably frivolous as the English will never have good cooking. The English, though blest above all nations that are or ever were with the knack of producing poets, do not take art seriously either : whereas the French, who have produced no Shakespeare, no Milton, no Dante, no Tolstoy, no Giotto, no Piero della Francesca, no Raphael, nor yet a Rembrandt, take solemnly almost, because they are amongst the best things in life, paint and letters. Their standards in consequence are above those of all other nations, and they have produced and will continue to produce books and pictures to hold their own in any company.

English frivolity is something no ordinary Frenchman can understand ; and it would astonish a cultivated bourgeois, though not of course a highly educated French intellectual, were he to catch a glimpse of those depths of scepticism in which quite ordinary English people take refuge. Likewise very few French poets have felt comfortable in the rarefied regions wherein most English, once they have cut the cable and let the balloon rip, make themselves only too serenely at home. Yet though they seldom fly so high but what they can stretch out a wing and brush the earth, French artists are not *terre à terre*. Compare a still life—a loaf of bread and a bottle of wine—by Chardin or some lesser but still gifted genre-painter with a piece of the same kind by almost any reputable Dutchman (bar Rembrandt), and you will probably notice that, whereas the Dutchman has translated into admirable paint no more than a simple esurient satisfaction, the Frenchman, if he be of any mettle, will have composed, digging deeper into common experience, a little hymn to the beauty of bien-être.

12

Less passionate than Italians or Spaniards, more exalted than Dutch and Netherlanders, French painters have made their own that world of significance which hangs like autumn mist above the soil. To the exploration of this they have devoted all the inquisitive and acquisitive powers of the French intellect; nor have they ever wanted technical ability with which to realise in concrete form the discoveries of the spirit. And always—mark this—or almost always, when it comes to realising those strangely insistent emotions, those inexplicable agitations, those itchings of inflamed sensibility which are the stimulants of all artistic creation, the creative fever is controlled by that queer thing which we call taste. Taste, which is first-cousin to the three sisters Reasonableness, Sense and Manners, but, to the best of my belief, has so far evaded exact definition, is one of the notable characteristics of French art. It is as noticeable in the sculpture at Chartres as in a picture by Matisse, in a frock by Chanel as in the palace of the Institut, in the ensemble of a shop-girl as in the prose of Mérimée.

13

It is characteristic then of French painting that the painter tends to find inspiration in the subtleties, the overtones, the finesses of the world in which he lives rather than in a world of metaphysical abstraction or aerial phantasy. There is neither a French Greco nor a French Piero di Cosimo, just as there is no French Dante or Shelley; but there are Poussin and Chardin, Corot and Courbet, Renoir and Cézanne. You may call French painting realistic if you realise that the subtlest communication between two beings in perfect sympathy is just as real as a poke in the eye. French painting is realistic and humane. It is not often brutal, because it is not so much the brutality of facts as their beauty or interestingness that arrests the French painter's eye and catches his imagination : but the fact is always there; the French painter keeps his eye on the object.

French art is realistic and reasonable. Strictly limiting intention to capacity, a French painter will not often bite off more than he can chew, or, if you find the image inelegant, will not often try to say more than

14

he thinks. Taste and tact are character-
istics. French painting is seldom aggressive.
Assuredly French artists do not lack con-
viction ; but if they can speak the whole
truth as they feel it without losing their
manners, why so much the better. That
is why by superficial critics French art has
been judged conventional. Unconsciously
the most rebellious are inclined by native
taste to respect the national tradition ;
hence that repeated and ever agreeable
surprise of discovering and rediscovering
how traditional in fact are those very pic-
tures which once were deemed last words
in eccentricity. The hubbub caused by
the Impressionists was if possible greater
than that provoked by the Post-Impression-
ists, yet the other day when in a private
collection I saw hanging on one wall
pictures by Renoir, Matisse, Fragonard and
Watteau, what struck me most, apart from
the beauty of the pictures, was the even
tenour of the way kept by French painting
for more than two hundred years. Always
it has been tactful in the best sense of that
abused word, always it has aimed at the

maximum of elegance compatible with sincerity. From the days of Fouquet, from the days of Chartres, French artists have preferred to give pleasure so long as giving pleasure was compatible with telling the truth—truth to their vision, I mean.

Last characteristic and best : French painters are content to be painters. With admirable clarity they distinguish between painting and literature. They understand that since they are painters all those subtle things for which they care, and of which I have tried to adumbrate the nature, have got to be transmuted to line and colour. Their art begins and ends in the world of visible things. If there is no El Greco, there are no pre-Raphaelites either in French painting ; or if a few there be we hear very little of them.

And now back to the beginning. But first let me say that beginnings are not necessarily origins ; that though there are French primitives they are neither the *fons* nor the *origo* of what I consider the French school. Indeed, as I have said and must repeat, it seems to me—I speak with all the courage of ignorance—that in the Middle

Ages there was no French school, if by
" school " you mean a source of original
ideas and technical processes, nourishing
artists and purveying influences, and if by
painting you do not mean painting on glass.
There were provincial studios and work-
shops, some of which became at moments
(*e.g.* in Paris about 1400) of international
importance, but which are found, when all
has been said that fairly can be said, to have
drawn their sustenance from one or other of
the great centres, from the Flemish or from
the Italian, or as often as not from both.
Nevertheless, these provincial studios gave a
flavour of their own to what they borrowed ;
and in so far as that flavour differs from the
predominant Flemish or Italian, and re-
sembles that which throughout the centuries
has clung to the produce of France, we are
justified in calling it French. Thus in the
Middle Ages we have, if not French, at
least Frenchified painting. Better still we
have French painters. Here and there,
I mean, and now and then, arises an artist,
endowed with or having acquired the dis-
tinctive French characteristics, who has the

strength to impose on matter borrowed from afar the mark of his individual genius. We have the mural masters of Saint-Savin and Montmorillon, living on the Byzantine tradition but adding something not strictly hieratic ; we have the Flemish-born Pol de Limbourg, very Flemish and a little Italian, yet acquiring a new and gracious naturalism which is neither ; we have Jean Fouquet— unmistakably we have him—and Enguer-rand Charonton and le maître de Moulins. I wish I could claim as confidently the master of the *Pietà* : but does he strike you as essentially French ? Anyhow we have Jean Clouet, half of whom belongs to the Middle Ages. And yet it is significant that but one of these, Fouquet, is quite certainly of French origin, though Charonton is said to have been born at Laon.

About French illumination in the eleventh and twelfth centuries I propose to say nothing, partly because this is an essay, partly because I know nothing. Apparently it was an ecclesiastical art, produced in the monasteries; and seeing that in those days the religious houses on the Continent were

as cosmopolitan as the grand hotels in ours, it seems unlikely that their art should have been specifically French. Perhaps that is why the English illustration of the period is more to my taste ; certainly it is less conventional. I know of nothing then producing in Western Europe comparable in spirit, delicacy and daring with the Winchester Bible. No, if I am to name the earliest examples of French painting proper, I would propose the mural decorations. The paintings at Saint-Savin are not all of an epoch ; the best are supposed to date from about 1100 : those at Montmorillon can hardly be earlier than 1200. Of this twelfth century wall-painting we shall certainly see more as the white-wash and grime of seven hundred years yield to the indefatigable energy of archaeologists. Meanwhile it is agreeable to remember that the pioneer, the archaeologist to whom is due the discovery of these noble and historically all-important paintings, was also one of the best prose-writers that ever lived. In the year 1845 to deal with this bewildering, isolated, and unlooked-for fact in the history

of art, which was the discovery of undated and seemingly undatable wall-paintings at Saint-Savin, required nothing less than genius : luckily there was plenty of that chez Monsieur l'Inspecteur de monuments historiques, for M. l'Inspecteur was Prosper Mérimée. The paintings at Saint-Savin are in the romanesque manner, that is to say they are Byzantine modified by the naïf vigour and sensibility of western barbarians. The style, in its admirable simplification, its insistence on the general and disregard of realistic particularities, is Byzantine ; but the paintings have other and younger qualities. No intelligent visitor but is surprised by the freedom of the brush-work. Gaily the scruples and conventions inherited from Byzantine mosaicists, and hitherto by painters religiously observed, are sent sailing down the wind. Here is an artist with a modern sensibility who expresses himself through that most modern of mediums, handwriting. And when you are at Montmorillon do not overlook that gesture of he Virgin who, as the infant Christ puts he mystical ring on the finger of St.

*PLATE I*

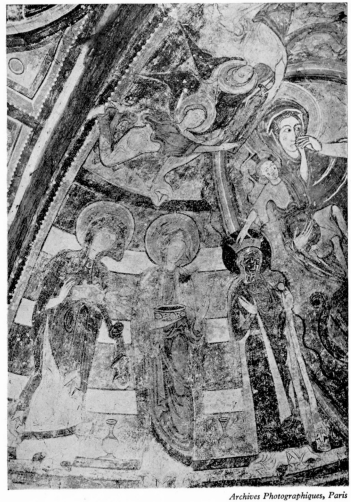

Wall-Painting at Montmorillon About 1200

Catherine, snatches up the free hand of her baby and gives it a kiss ; for here is a touch, startling in these early days, of that sentiment trembling on the brink of sentimentality with which only French artists, and Sterne and Goldsmith perhaps, can safely play.[1]

During the twelfth century the influence of Saint-Savin appears to have radiated over the centre, and more especially the south-west centre of France : one speaks of the Poitevin school when one wishes to be even with an archaeologist. The tradition was inherited, not by the illuminators and miniaturists, but by those magnificent artists who gave us the glass at Chartres and Bourges. Here, in the thirteenth century, we have the grand French painting of the Middle Ages; here we have a school indeed, a school however which it is none of my business to describe. Glass is the legitimate successor of mural painting, seeing that of mural painting it took the place ; for when Gothic architecture took the place of Romanesque the window took the place of the wall.

[1] About illustrations : from thirty-two photographs, which is as many as I have room for, you will not expect a representation of French painting. I use them wholly to support the text.

But about this verrier's art, all I can allow myself to say is that it was a purely French affair, which, if it did receive anything from abroad, gave far more than it got. Its influence spread wide ; for, whether all the glass was actually made at Chartres, or whether, as seems more likely, artists and artisans transported themselves and their apparatus to the places where their work was in demand, certain it is that this work is to be found not only at Bourges, Tours, Sens, Rouen and Le Mans, but as far afield as Canterbury and Lincoln.

The illustrators (miniaturists and illuminators), who towards the middle of the fourteenth century abound in and about Paris, bear no relation whatever to the monumental masters of Saint-Savin and Montmorillon. To the glass-makers, on the other hand, their debt is unfortunately apparent, for a good many of them tried to obtain the effects proper to a translucent medium, and failed. The dominant influences, however, are still Flemish and Italian ; the native contribution (apart from influence of the glass-makers) being no more than a touch of

realism, a more acute observation of nature, a smack of that French subtlety which generally creeps in when an artist living in France succeeds in giving plastic expression to common experience. It is to be noted that the art of the illustrator, having escaped from the monastery, becomes now far less conservative ; stimulated by Flemish examples, the Parisian workshops experiment freely, and almost always in the direction of naturalism. Also this fourteenth century provides us with a name or two for the comfort of historians. As early as 1304 we find one Errard d'Orleans described as " peintre du roi "—the first occasion on which the title appears, and Jean Pucelle is known to have been at work in Paris by 1320, Jacques Maci by 1327. These must suffice to keep the historian happy till 1359 when he can pounce on the portrait of Jean le Bon (now in the Louvre) attributed to Girard d'Orleans. This, he will hasten to tell you, is a real transportable picture, painted on wood covered with canvas, which canvas has in its turn been covered with gilt plaster. May I add on my own account that it is no bad picture

either, being a piece of frank, unflattering realism, nicely painted ? But the word is with the historian, and he shall point out that it was probably done in London at the time when Jean and his retinue—including his painter—were prisoners of Edward III. So here you have a portrait of a known person painted at a more or less known date by a more or less known artist ; and this you will perceive is an event of the first importance. The historian here comes into his own, and from this out you can if you like forget all about works of art in the pleasing pursuit of names and dates. Let him, the historian, not omit to remind you that about the year 1370 was born Hubert Van Eyck ; for the Van Eycks, though they did not, as Vasari and other historians have supposed, invent the craft of oil-painting, did revolutionise the craft of representation.

Towards the end of the fourteenth century something like a school, a clearing-house for multifarious tendencies, would seem to have been forming in Paris. There is an inclination, natural enough in patriotic savants, to make the most of this essentially eclectic

movement. That the task of magnification is arduous may be surmised when one catches a scholar so distinguished and generally so careful as M. le Comte Paul Durrieu writing as follows : " Parmi ceux-ci (those painters working in Paris during the fourteenth century of whom we know so much as the names) certains, d'après la faveur que leur ont temoignée les rois et les princes, ont dû être de vrais artistes " (Michel, *Histoire de l'Art*, III, i, p. 122). If ever the merits of nineteenth and twentieth century artists should come to be appraised on M. le Comte's system, historians will arrive at some odd conclusions. Certainly royal patronage was important : Charles V and his brothers—the Duke of Berry, the Duke of Anjou, and Philip the Bold—were all collectors ; and so was Charles VI, his son, who unluckily went mad. The great gentlemen and high officials, and still more the fine ladies, could hardly do less than follow such a lead. It was all a little snobbish I dare say, though preferable to the modern method of merely asking artists to lunch. Nevertheless, whether such patronage creates the

atmosphere most favourable to the expression of original genius is an open question, and one on which happily I am not obliged to speak. What is certain is that during those years that lie between the death of Edward III and the accession of Henry V—if I enclose a brilliant period in French history between two English dates, my meaning will not be misunderstood—Paris revelled in unheard-of wealth and elegance. The court civilization appears to have been cosmopolitan, coloured by Italian, Flemish and German fashions : so was the art, Flanders, Siena, Cologne being all visibly influential. Is it not significant that the Wilton triptych, a work of this period and a charming one, though almost certainly of Parisian workmanship, has been attributed by experts to Italian, German and even English studios ?

1400 : at last we have a plethora of names, of which the greatest is Limbourg. There were three of them, brothers, all at one time or another between the years 1380 and 1415 in the service of the Duke of Berry. They were Flemings by origin, from between the Meuse and the Rhine, and they have left us

*PLATE II*

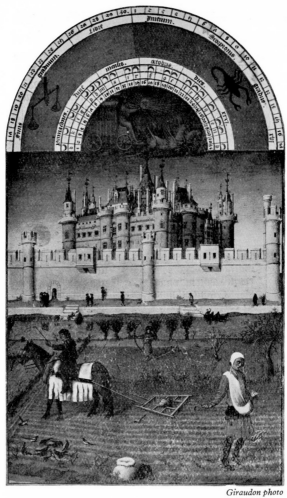

Pol de Limbourg          Très Riches Heures

one considerable work of art, *Les Très Riches Heures*, executed for the Duke of Berry and unfinished when he died in 1416. Those famous pages which one can see with some difficulty at Chantilly, and which are generally reckoned the work of Pol de Limbourg, are the work of a Fleming admittedly; and yet here we have painting which in its unobtrusive naturalism, its clear, intelligent emotion for the country—the country round Paris—its tactful but sturdy insistence on human values, its almost supernatural power of rendering facts, and its grip of form, is surely French.   We may think of Corot if we like, especially if it will save us from speaking of Jean François Millet.

When Henry V entered Paris, ruining the capital and the whole Ile de France and incidentally setting back the clock of European civilization, the painters dispersed.   Some fled to Burgundy, the ruler of which great province was at war with the French king and in league with the English, and there, under Flemish and German suzerainty, developed an art for which I do not greatly care and which strikes me as

profoundly unFrench. Melchior Broderlam is the great figure amongst these industrious artisans, and his too famous retable (now in the museum at Dijon) seems to me hardly more French than his name ; it is just a pretty exercise in the Italianate-Flemish manner, much to be preferred to the distressing productions of that other glory of Dijon, Claus Sluter. Meanwhile those who fled to Touraine and the valley of the Loire were founding a provincial school more purely French than anything we have yet come across. Here for the first time we are in the presence of an unmistakably French painter, for Jean Fouquet (about 1415–1480) is unmistakably French. Not but what the Flemish strain is still potent ; and like any other Frenchman he went to Italy and was duly impressed. As a miniaturist —and he was a miniaturist originally—he is only a little more than an honourable representative of a reputable tradition, but it is as a painter proper that he stands out in the history of art : in painting proper he is an innovator. Sound, sensible, without an ounce of pretentiousness in his nature,

*PLATE III*

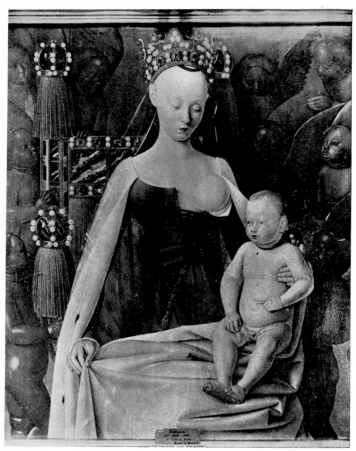

*Giraudon photo.*

Fouquet        Vierge à l'Enfant (Agnès Sorel?)

he kept his nose to the ground, and, without the slightest velleity towards "chic," his eye on the object ; only that hunting nose was more delicate, that eye deeper seeing, than those of common illustrators. Like the good Frenchman he was, he loved the good things of life—wine, women, well-laid tables, gardens, rivers, and the sky ; only he loved them with a love passing the love of viveurs and sportsmen. Also he rendered them, those fields and rivers and skies of his sweet and temperate Touraine, with a gentle fluency, an atmospheric realism, a sense of spaces and distances entirely new in French painting. We have a portrait of him by himself, the earliest portrait of a French painter in existence I should think, and it is satisfactory to find the head of a sensible, humorous peasant, without airs or other insignia of genius, worthy ancestor of a long line of splendidly solid masters—Claude, Chardin, Corot, Monet, Cézanne. They are beginning to say, I know not why, that the Virgin of Antwerp (here reproduced) is not after all a portrait of the adorable Agnès Sorel—adored by Charles VII and

by all good Voltaireans deep in *La Pucelle*.
All I can do about it is to point out that the
head of the Virgin bears some likeness to the
head of the royal mistress in that portrait
on which Francis I scrawled his well-known
lines :

> " Plus de louange son amour s'y mérite
> Etant cause de France recouvrer
> Que n'est tout ce qu'en cloistre peult ouvrer
> Close nonnayne ou au désert Ermyte."

Anyhow the genuineness of the portrait
has nothing to do with the authenticity of
the picture, nor with its artistic value, which
is considerable. This school of French-
Flemish portraitists, founded in the fifteenth
century, was to linger on in ever-increasing
fertility and decreasing significance right
through the sixteenth. It thus becomes the
one thing more or less French, and almost
the only thing respectable, in that unpleasant
Italianate epoch of which I must speak in
my next chapter. Its merits and limitations
are visible enough in the charming por-
trait—some say it is of the baby son of
Charles VIII—which I here reproduce.
About this picture (painted in 1498 or there-

*PLATE IV*

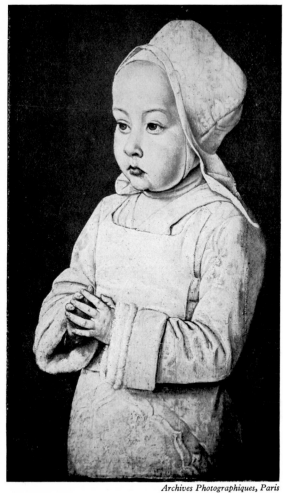

About 1498                    Portrait d'Enfant

abouts) the thing to note, when you have had your fill of its partly human charm, is its directness and its honesty. No theory of representation has come between the artist and his vision : there is no showing off, no flourish, no trick of the trade. On the other hand it is not profound : there is no discovery of the deeper significance of forms : there is more statement than expression. A hundred years later there will be no plastic expression at all, nothing but statement.

When, in the dingy little museum at Autun, I came on its treasure, that charming Nativity, I took it for a Flemish picture, the work of one of those Italianising Flemings of the late fifteenth century. Mr. Roger Fry, however, assured me that it was by the maître de Moulins, so to Moulins I went. At Moulins, in the latter part of the fifteenth century, an upstart family, the Bourbons, was attempting to form a provincial court, to which drifted naturally a few itinerant painters. Of these the sole known to fame is this mysterious master whose triptych is still to be seen in the treasury of the cathedral.

It is a remarkable picture ; though when you hear that for many years it was attributed by experts to Domenico Ghirlandaio you will guess that it is not a world-shaking masterpiece. Indeed a way of measuring pretty fairly the distance between French and Italian primitives is to remind yourself that the Moulins and Wilton triptychs are amongst the masterpieces of the former, and that one has been taken by admirers for a Ghirlandaio, while the other, compared with its neighbour in the National Gallery—the Fra Angelico predella—appears definitely second class. At first sight this picture looks Flemish, and Flemish a good deal of it is ; then you notice the lovely angel at the top and the composition of the central panel and you begin to wonder whether after all it is not Italian. Only when you come to peer into the details— and in the details are to be found the chief beauties—will you discover—in the heads for instance of the supporting angels— things neither Flemish nor Italian, which can be only French. Looking at this picture makes one regret more than ever that

*PLATE V*

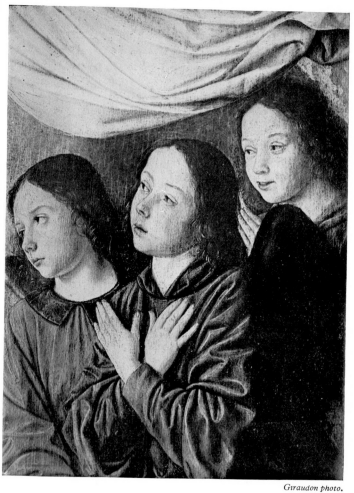

Le Maître de Moulins

Triptych (détail)

French painting, instead of being allowed
to assimilate gradually the prevailing influ-
ence, was made to swallow at a gulp such
a monstrous mouthful of Italianism as left
it with a hundred years of belly-ache.

In the general post of Parisian painters
caused by the English occupation, a few
found their way to Avignon. Ever since
1305, when the popes set up house there,
Avignon, on the road from north to south,
had been a centre of international culture.
The palace was decorated by Italians ; but
of these decorations only the mural paintings
in the Garderobe (1344) remain. They
are the work of an Italian whose art has
been coloured by his circumstances, of
a provincial Simone Martini—Matteo di
Viterbo was his name—who has caught the
French passion for " la chasse." The out-
of-doors naturalism is French ; the beautiful
contempt of realism and the turn for stylisa-
tion are Italian : the whole thing is delicious.
Unluckily, to the tourist it is inaccessible
almost ; for he is hurried by an obligatory
guide through the painted chamber to
various apartments in which at one time or

another events of historical importance are supposed to have occurred. He must not loiter. There are rooms to be seen in which resisting female protestants have written their names, and the French government is perhaps afraid that if left alone he will write his across the frescoes of Matteo di Viterbo. Seeing that successive French governments have allowed all the other paintings to perish, this solicitude is natural and commendable ; but why not provide the Garderobe with a caretaker ? I do not know. All I can say is that the last time I was in the palace it was with great difficulty and after much trapesing that I was allowed, as a special favour, to spend twenty minutes with these enchanting decorations. And all I can say to the cultivated tourist is what the county council says in another connection—You have been warned.

In 1378 the Pope returned to Rome. But Avignon, though without the trade and industry which enriched those towns of northern France and Flanders where painting flourished, contrived to keep open her

PLATE VI

Enguerrand Charonton          Le Couronnement de la Vierge (détail)

cosmopolitan studios; and these in the fifteenth century were to produce two artists, one of whom has left us a lovely masterpiece, while the other has created something of a kind and quality very different from anything produced elsewhere in France during the Middle Ages. I am not thinking of Nicolas Froment (at work 1461–1482), whose famous altar-piece in the cathedral at Aix does not seem to me of extraordinary merit and is in any case purely Flemish. I am thinking of the master of the *Pietà* and, though he stands much lower of course, Enguerrand Charonton. Enguerrand Charonton came from Laon, they say, and in 1453 painted that *Couronnement de la Vierge* which is to be seen at Villeneuve-lès-Avignon; the *Pietà*, also from Villeneuve, appears to have been painted about 1440 and is now in the Louvre. It has been suggested that this masterpiece is the work of a Catalan. I can hardly believe it. I am pretty well acquainted with the collections at Barcelona and Vich and I saw the exhibition of 1929; I saw nothing like this. Surely the spirit of this grandiose and tragic

work—in some ways very French, mark the head of the donor, a wine-grower from Les Bouches-du-Rhône—is Italian. Anyhow we are as far from the world of those charming Limbourgs as from that of the excellent Fouquet : about this picture is nothing descriptive, it is wholly expressive. Not here is painting used to point a moral or adorn a tale, to describe a situation or convey the charm of a woman, a child, or a flowery field. But here is emotion expressed passionately in purest line and colour, in forms that live and have significance, not by reference to external reality, but in a world of their own. Our delight in descriptive painting must be largely a matter of mood : we bring our own with us, with which, if the picture chime, communication is established and we get our little ecstasy. But the man who painted that *Pietà*, though dead these five hundred years, still waits for us and imposes on unwilling moods his own. We are in the world of Masaccio and the Lorenzetti—of Dante if you will. Here is the greatest painting produced during the Middle Ages in what is now the land of France.

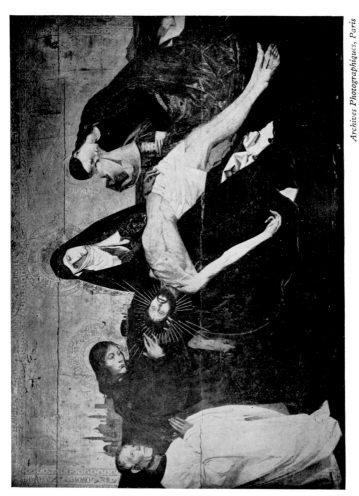

Le Maître d'Avignon

Pietà

*PLATE VIII*

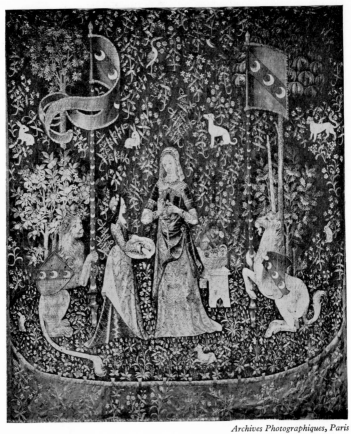

Tapestry (about 1500)      La Dame à la Licorne

Before turning to the sixteenth century, and the impact on France of the high Italian renaissance, I should like to reproduce one more work of art. It is a bit of that famous tapestry which is the pride of the Musée Cluny, *La Dame à la Licorne*. It is as French as French can be. Here you will recognise all those characteristics which I have tried to indicate in this first chapter and would beg you to bear in mind throughout the essay—realism that never quite touches earth, humanity that just steers clear of sentimentality, a sense of the pleasantness of life, taste, elegance, a love of objects for their own sake and the art of rendering them truly but not literally. This lovely thing is so well known that I must not stay to admire it, but rather make it an occasion for observing that in the fourteenth and fifteenth centuries tapestry was perhaps the most characteristic expression of the French genius for visual art. Now tapestry-making was essentially a Flemish craft. The great and rich of northern and central France smothered their walls with it, and anyone who knows

the climate and the cold comfort of paint will sympathise with their preference. Wherever they went they took their hangings with them, and thus wore them threadbare in the end. Very few have come down to us, and those few for the most part in wretched case. I have never had the luck to be at Angers at the time when they show in the cathedral the series of the *Apocalypse* (1378) ; but I have been to Beaune (whither are other attractions besides the hangings and the Roger Van de Weyden) and gazed on those mid-fifteenth century marvels in the sacristy : meanwhile, any day of the week, except Monday, we can delight in *La Dame à la Licorne*. Maybe, instead of wasting time over half known and not so very well worth knowing miniaturists, an essayist should assert dashingly that the history of French painting in the Middle Ages (apart from half a dozen pictures of dubious nationality) is, in the twelfth century wall-painting, in the thirteenth glass, in the fourteenth and fifteenth hangings.

If you will stop here and take a final glance, at the road I was going to say, at

the devious paths and sheep-walks rather, by which we have cut across that uncharted but pleasant and flowery land which is the history of French painting in the Middle Ages, you will agree, I think, that you can see nothing fairly to be described as a metropolitan school. So far we have come on no centre of production giving birth to those suggestive ideas and fertile methods which, as they spread outward, animate and sustain dependent and minor movements. We have seen nothing of that sort in the history of French painting yet. We have seen that between 1300 and 1550 there was such a school in the Netherlands, a school to which northern and central France was much beholden ; while from Italy came the grand all-conditioning influence. The rise and fall of schools may have something to do with geography and history, but the connection is not direct. There is no obvious reason why a metropolitan school of painting should not have arisen in medieval France, seeing that a metropolitan school of architecture did—to say nothing of internationally important schools of

sculpture and glass-making. Whatever be the story of its remote origins, Gothic architecture, as we know it, sprang to life in the Ile de France in the twelfth century and with incredible speed imposed itself on Europe—yes, for a while, on Italy even, northern Italy at any rate. Again, that school of sculpture which is sometimes called the school of Rheims, sometimes the school of Chartres, and in the dawn of the thirteenth century went beyond anything in Italy, that, too, established itself for a moment as an international influence, established itself less securely alas ! As for the verriers, we have traced their influence as far as Lincoln anyhow. But what is important about these three schools, far more important than any territorial infeodation, what is significant to our purpose is that all drew their nourishment from the very soil and centre of France. That is what cannot be said of any medieval school of painting.

French architects were not content to go on building in that romanesque style inherited through the Lombards from Byzantium : they invented and elaborated Gothic.

Meanwhile French painters continued to find nourishment in the schools of the Netherlands and of Italy. When Louis XI began seriously to unify the kingdom, the painters still looked without for inspiration. When Henry IV, Richelieu, and Louis XIV had completed the task, French painting became national more or less, though not self-supporting. By the beginning of the eighteenth century French painting had become, not what it was to become in the nineteenth, dominant, but—shall we say, ascendant. Should we relate this ascendancy to politics ; or rather to the decrepitude of Italian culture ? Do as you please. All I want to agree about is this : until Poussin, breathing new life into moribund Italian eclecticism, and Rubens, master of us all, had created the French tradition, no such thing as a French school of painting proper can be said to have existed. However, as I could not well begin an essay on French painting with the departure of Poussin for Rome, I have said my little say about the illuminators and the miniaturists and the painters of the fifteenth century ;

and now I must devote a short chapter, a very short one, to that lamentable experiment which gave us Fontainebleau—the attempt to impose Italianism at its flashiest on French civility. That done, I can get on to Poussin and the great tradition.

## *ITALIANATE*

IN those far-off days when Italians were funny at the expense of other nations there was a saying : *Inglese italianato è diavolo incarnato*. In the sixteenth century Italianisation seems to have had much the same effect on the Francese. With Fouquet and Villon, Agnès Sorel and that picture of a baby we have just been admiring, I feel myself still in a world not utterly strange, still in that France which I think that I know and know that I love. But from beginning to end of the sixteenth century, between *La Dame à la Licorne* and the Place des Vosges, we are in a world of hard, unfriendly, snobbish supermen who have the air of invaders in la douce France. On the banks of the Loire, at Chantilly, at Fontainebleau, all over the land they set up their tactless, ostentatious houses, fit residences for nouveaux riches, which have had to wait four hundred years for the finishing touch —an Hispano at the door and a telephone

in every room. It was they who hired, because there were then no professional photographers to perpetuate in silver frames their memorable features, that tribe of professional likeness-catchers, most of whom now pass under the name of one or other of the Clouets. Why, even of their charming poets they made pedants. They fought, they poisoned and they stabbed, they tortured, betrayed and swaggered, more to prove what fine fellows they were than to gain any serious advantage. Love, which in better days is at lowest sublimated lust, was with them more often than not unmitigated vanity. They could not be simple, they could barely be quiet : theirs was the self-consciousness of *h*-less millionaires in farces and bulls in china-shops. They were intolerable.

They were intolerable because they were northern hearties masquerading as maturely civilized Italians. They were making the common mistake of supposing that there is a short cut to culture and that civilization is to be hired. What happened was what one would have expected to happen. Three

hundred years hence a lover of Japanese civilization will probably look back with disgust at the later nineteenth and twentieth century and condemn the period as the least Japanese in Japanese history. For let us suppose that this greatly gifted race assimilates in a hundred years or so all that it needs of occidental culture and thus enriched returns to its own; will not future historians have something of this sort to say :—" In the nineteenth century Europe and America were leading humanity along the way of the world (a deplorable way as it turned out) ; into that way it was necessary for Japan to enter if ultimately she was to save her individuality and take a hand in shaping the future ; in the process, however, she was bound to play sad tricks with her native culture. Europe," the historians will continue, " had been to some extent prepared for the nineteenth century by her past, so, though she slipped into modern clothes with an ill grace, she did not look fantastic in them, whereas the change from oriental dress to top-hats and trousers was altogether too violent for any saving sign of continuity.

Thus . . . etc., etc., etc." And so it was with France in the sixteenth century. By 1515 Italy was already far down that road which the whole western world was to travel. This Francis I, a stupid, vulgar man, recognised stupidly and vulgarly. Wherefore he decreed that France should have Italian fashions, quite forgetting, or rather failing to perceive, that Italian fashions in the year 1515 were the fine flower of five hundred years of Italian history, of fifteen hundred if you please. All he perceived was that Italian things were the right things : Italian houses, pictures, poetry, music, food, drink, clothes, jewellery, women, diseases, doctors, magicians, mountebanks, philosophers' stones and philosophies of life, why should not France have them all, since France was powerful and rich ? One seems to have heard something of the sort before. In Rome of the first century was it, or in Chicago the day before yesterday ? Anyhow, throughout the sixteenth century the Italian thing was the right thing, the thing one was admired for possessing and paid through the nose to possess. Also the Italians of the

Renaissance had cultivated and magnified personality, the *ego* had blown itself out like a pumpkin on a dung-hill : the French aristocrats learnt that lesson too and bungled it in learning. They would be supermen, but instead of being supermen who created their own Walhalla they paid for admission ; yet, paradoxically enough, were themselves self-made. They had bought Italy with her culture and her arts ; now they would enjoy her. As for taste wherewith to enjoy, that comes easily to the rich : they order it along with the rest from Bond Street or Rome. Taste is patronage. Let us see what this self-glorifying patronage made of French painting in the sixteenth century.

As early as 1508 the Cardinal d'Amboise, that imperialistic prelate, as unlucky for France as lucky for himself, had brought Solario to Gaillon, there to decorate his fine new place. One could wish it had been Solario rather than Primaticcio who stayed to impose Italian style ; but the battle of Marignano had yet to be fought and France was not yet ripe for the infection. Ten years later came Andrea del Sarto and painted

that admirable *Charity* now in the Louvre. They sent him back to Italy with a pocketful of cash to buy masterpieces, and he, feeling that after all charity does begin at home, stayed there. Next was dragged in the venerable Lionardo himself : he was seventy years old when he reached the land of promise, and it killed him out of hand—1519. After the sack of Rome eight years later, and the collapse of the Florentine republic, a good many Italian painters found themselves *en* what they call at the Foreign Office *disponibilité* ; and two of them, Primaticcio and Rosso, were summoned to France, installed at Fontainebleau, and there put in charge particularly of the decoration of the château, generally of French art. Primaticcio is a typical second-rate practitioner of a second-rate age. He was what they call a stylist, which means that he had acquired by study all those tricks which, when the masters invented them, were not tricks at all but means of expression ; also he could put them to any conceivable purpose save one. The one purpose to which he could not put them was that of expression, for the very sufficient

reason that he had nothing to express. The only ends he could conceive were the acquisition of money and fame, which, when pursued with absolute single-mindedness, rarely inspire great art. Primaticcio arrived in 1532 and it took him eight years to get rid of his colleague Rosso, who is supposed to have killed himself in a fit of remorse induced by having falsely accused of fraud his too successful comrade Pellegrini : anyhow Pellegrini was duly tortured and executed and Rosso died. So far as it is concerned with Rosso's state of mind the story may or may not be true ; the fate of Pellegrini appears to be certain, and throws some light on life in artistic circles at Fontainebleau. Meanwhile Benvenuto Cellini had paid a visit to these old friends of his who seemed to have struck oil in France, had a row, and departed. Primaticcio ruled in lone splendour. He ruled, all told, for thirty-seven years and in 1569 was gathered to his fathers.

Of this first Fontainebleau period the only French names I recall are Jean Cousin, Claude Badoyn, Charles Carmoy, Dorigny,

Caron, and the Dumoustiers of Rouen : of their work very little remains, and of that little I know next to nothing. So far as I remember it follows at a respectful distance —naturally, since it was with difficulty these Frenchmen acquired the Italian idiom —the work of their teachers, Primaticcio, Rosso, Nicola del Abbate. It is feebly decorative and provincially stylish : mean forms, recognisably reminiscent of Guido Reni, spread themselves over vast spaces, signifying nothing. The best of the bunch is old Jean Cousin. Of his chief title to fame, that of having lived for about a hundred and seventeen years, they have deprived him, it having come out lately that there were two of the name, father and son. Jean Cousin the elder, who died in the 'sixties, is the author of the work here reproduced, *Eva Prima Pandora*. The very title suggests a pleasantly school-boyish pedantry, and the picture with its baroque elongations and exaggerated Bolognese drawing is not without beauty. Like so many of these Fontainebleau nudes—you will find more in the second phase, after 1572 that is—it has

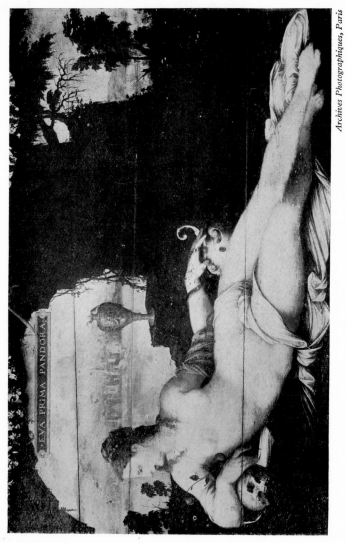

Eva Prima Pandora

Jean Cousin, le père

a curious provincial lubricity which is not unpleasing either. In the sixteenth century, you must remember, French painters were still unaccustomed to using the human form as a means of plastic expression. Themselves, they had still one foot in the world of rustic prudery and prurience, while to their public a nude was still something deliciously disquieting if not downright naughty. Do you not catch before these Fontainebleau Venuses and Dianas the echo of a titter, as of some Parisian commercial traveller stopping his adoring and endimanched country cousins in front of *La Source*—Tiens, une jolie femme toute nue? There is a touch of Henner about these naked nymphs; and it seems to me significant that many of them have been credited, quite unwarrantably, with the names of great ladies and royal mistresses, Diane de Poitiers, Gabrielle d'Estrées. We are in presence of painters who cannot take quite simply a naked human body as an aesthetically significant fact, which was of course how for a hundred and fifty years the Italians had taken and how Primaticcio and Rosso took it; and of a

public which felt for their pictures something not unlike what readers of illustrated papers feel for photographs of celebrated beauties on the Lido. This understood, we shall pardon readily enough ; for, to be frank, this naivety gives to the Fontainebleau nudes a charm which, in the right mood, one only too easily exaggerates. As for the long picture by Jean Cousin the elder, maybe it pleases also by reminding us a little of the one great French artist who, indirectly, did come out of Fontainebleau—I mean, of course, the sculptor, Jean Goujon.

Primaticcio, I said, died in '69. The French will call him Primatice just as they call La Principessa degli Orsini, Madame des Ursins. The practice has its dangers : for instance, not so very long ago, when I was lunching in the house of a lady who bears a great French name, in rushed, late and excited, a collector brandishing a drawing and exclaiming in English (he spoke English because his hostess, name notwithstanding, spoke nothing else)—" See what I've picked up for a hundred francs, a Primatice ! " " Why, Mister Chose," snapped the grande

dame, "you know very well I care for nothing pre Matisse and Picasso." Anyhow Primatice died in 1569. In 1572 came the massacre of St. Bartholomew, a distressing but characteristic incident in the religious controversy of the age, and the civil war recommenced with redoubled fury. Whether that had anything to do with it I know not, but about this time French painters took to living abroad—in Rome chiefly. On the other hand Flemish painters began coming to Fontainebleau.

I think I am right in saying that the painters of this second generation most famous in their day (1572–1620 say) were Amboise Dubois, Toussaint Dubreuil and Martin Freminet : towards the end of the period we find these last two ruling the roost as Primaticcio had ruled before them. Most of what they painted has perished and nothing is here for tears ; what remains consists chiefly of allegorical and historical compositions swept as rapidly as may be— they were paid by the piece—over vast spaces. The spaces are filled in the commercial sense of the word and no other ;

but the padding is blown out with an air of high seriousness, Amyot's translations appearing in the nick of time to provide themes on which to be furiously classical. At Rome these later Fontainebleau men had sat at the feet of such miserable masters as Zucchero and Pomerancio, and on this account partly, but chiefly because, having by now mastered the eclectic manner they no longer benefited by that anxiety and eagerness in discovery which almost always invigorate the work of men struggling with an unfamiliar technique, they are inferior to the disciples of Primaticcio and Rosso. Nevertheless, they gave France, and through France the world, something new : they invented the Prix de Rome winner. Their names stand at the head of that long list of humbugs who, having gone to Italy to learn the trade, without seeing anything of Italian art or understanding anything of the doctrine implicit in that art, return to Paris or London with a bag of tricks and stock of prestige sufficient to impress the middle classes.

Simon Vouet (1590–1649), the most gifted

of the tribe, shall represent it. He lies a little out of the period, being a contemporary of Poussin almost, to whose work his bears sometimes a superficial resemblance. He learnt at Rome all that was necessary to success ; and he was the most successful French painter of the day, admired not in France only but in Italy too, beyond measure and far beyond quiet old Poussin. He has any amount of talent and he displays every ounce of it. One can almost hear the connoisseurs of his day, and M. Dimier of ours, murmuring voluptuously " Tout Raphael est là " ; though in fact there is a deal of Venice into the bargain. His works abound, and they have often the air of works of art ; and that is as much of the matter as they have about them. Yet so plausible are they, so rich in artifice, that the Louvre even treats them with respect. So let us crown Simon Vouet and hail him founder of the dynasty : Prix de Rome et roi. I fancy he was about the first to go south, in no spirit of humility to drink at the source of wisdom, but to pick up tricks enough to beat the masters at their own game.

" From Vouet to Sargent," what a study in the macabre.

The best painter that can be remotely connected with Fontainebleau is Philippe de Champaigne. He was born at Brussels in 1602, so neither by birth nor date is he of our present business. Also the Louvre in a fit of surprising abnegation declines to claim him for France ; that is to say it claims him in the catalogue but in the gallery labels his pictures " école flamande." Why, after claiming so many primitives, to say nothing of the contemporary Pourbus the younger, who manifestly are not French at all, the venerable institution should become thus suddenly scrupulous, I do not know. Philippe de Champaigne came to Paris at the age of nineteen and there died in 1674, having made to the best of my knowledge but one excursion abroad and that to his native country. His art seems to me as French as that of the Englishman Sisley, which is not to deny that sharp critics can detect something exotic in both once they have been put on the track. He was the contemporary and friend of Poussin :

PLATE X

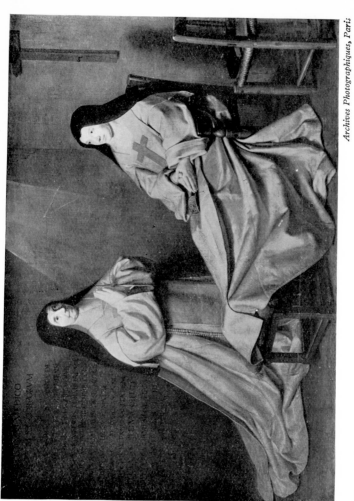

Champaigne

*Archives Photographiques, Paris*

La Mère Agnès et la Sœur Suzanne

but, as he painted always in the northern rather than the Italian manner, it would be inconvenient to write of him in my next chapter ; and as, in so far as he was influenced by Italy at all, that influence came presumably via Fontainebleau, I perhaps have some excuse for putting him in such bad company. Grave, sincere, mistrustful of emotion just because he was capable of feeling intensely—look at this reproduction —Philippe de Champaigne belongs to Port-Royal. He was the friend of Pascal and les Arnauld ; he painted a well-known portrait of *La mère Angélique* and this picture of *La mère Agnès et la sœur Suzanne* which is generally reckoned his masterpiece. The temptation to call his portraits Jansenist is irresistible. They are austere, they are alarmingly *digne*. You will say, perhaps, that he is a little too self-conscious in his self-denial, in his avoidance of any effect that can be easily obtained. Certainly he has a puritanical horror of the pretty and facile. Yet his portraits are never noble in the bad sense ; never does he try to stun our aesthetic sensibility with the moral

qualities of his sitter. He has a sure eye and feels for what he sees ; and what he sees and feels, and not one jot more, he renders magisterially. A great portrait-painter almost.

Meanwhile with the flashy, or would-be flashy, Italianate concurs a school of por-trait-takers, not great nor brilliant indeed, but genuine and genuinely French : the draughtsmen and miniaturists. Sometimes they are painters ostensibly working in colour, sometimes crayonists, sometimes draughtsmen who merely tint line-drawings ; but rarely does colour add much to the burden of their song, or rather of their prose. The super-men and women of the Renaissance who had to do without tele-phones and electric light lacked also photo-graphers ; but these limners did for them ad-mirably what photographers do adequately for their modern emulators, what royal academicians and sociétaires des Artistes Français try to do and fail : they created faithful and interesting records. Not one, I think, was quite a great artist—a great plastic artist at all events ; though Jean

*PLATE XI*

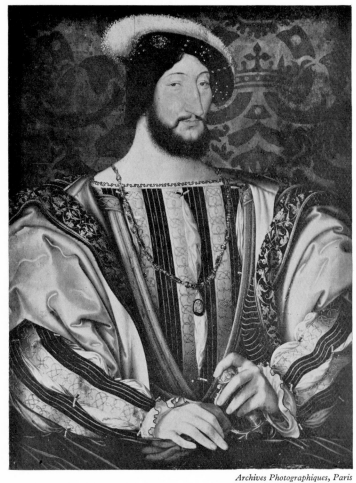

*Archives Photographiques, Paris*

Jean Clouet                    Portrait de François I

Clouet (1475–1540), François Clouet (1505–1572) and Corneille de Lyon (1505–1574) all at moments came near being something of the sort. The mischief is, they cannot conceive a head as a form aesthetically expressive in itself—to do so was no part of their business, I admit—so they conceive it as something humanly expressive. In their analysis, however, of these humanly expressive forms and in their statement of the result they are excellent. So far as their portraits are works of art they are works of literary rather than plastic art ; they are psychological. The characters they portray are the heroes and heroines of Brantôme, but they portray them with a subtlety and acumen far beyond the scope of that lively but simple-minded old scandal-monger. The visual medium is still in advance of the verbal, as it was in the Middle Ages, as it is in all rude societies[1] ; not till the maturity of Montaigne did France produce a writer as fully equipped as the sculptors of Chartres.

[1] At this point the reader will possibly think of the English sixteenth century and exclaim " Shakespeare ! " ; of the fourteenth even, and exclaim " Chaucer ! " Perhaps the generalisation should not be applied to societies so advanced as those of France or

It is not of Brantôme these sixteenth century draughtsmen make one think, but of La Bruyère.

Any portrait-drawing that by hook or crook can be dated somewhere between 1510 and 1572 is called, by the owner, a Clouet : any miniature of about the same period is ascribed to Corneille de Lyon. " Clouet " in fact is the name of a firm. I have mentioned already the eponymous father and son, who, by the way, were naturally of Flemish extraction, and professionally related to such Flemish and Rhenish painters as Holbein, Mabuse, Joos van Cleve : it is helpful to bear in mind that the elder was court limner to Francis I, the younger to Henry II, Mary Stuart and Charles IX. We know the names of a certain number of their assistants and partners, Pierre Viau, Jean Champion, Jean de Posay, and Denisot who painted the portrait of Ronsard's mistress. All were

England at the Renaissance : perhaps England, almost without a plastic art and of modern nations the literary *par excellence*, is an exception : or perhaps it would have been all right if I had said that painting and sculpture as means of expression were in advance of prose.

*PLATE XII*

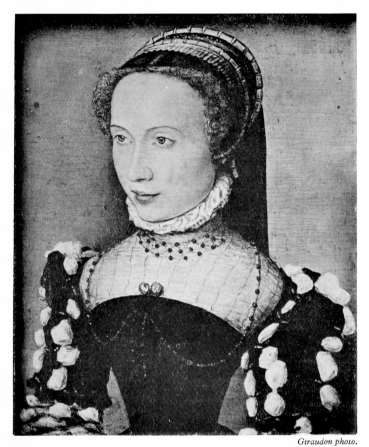

*Giraudon photo.*

Corneille de Lyon　　　　　Mde. de Martigné-Briant

driving a brisk trade about the middle of the century.

At the same time, another enterprise of a more frankly commercial nature was carrying on at Lyon under the direction of a Dutchman, known to fame as Corneille de Lyon. When the master himself gives a hand the product is generally satisfying. For Corneille in his small way was a master. He was recognised as such : and in 1546 Henry II made him painter in ordinary, giving him in the following year papers of naturalisation, while Eustorge de Beaulieu sang :

" Pour bien tirer un personnage au vif
  N'avait en France aucun comparatif."

Of course he is an observer, more observer than analyst to be frank. His style is that of the miniaturist, that is to say he shows us an enamel-like surface without modelling or relief or a glimpse of that handwriting wherewith an artist expresses the finer flickers of sensibility. If I have chosen to reproduce his portrait of Gabrielle de Rochechouart, at the time of her first

marriage, when she was about eighteen and about to become Madame de Martigné Briant, it is partly because the draughtsman's talent for delicate representation is here seen to advantage, partly because the likeness proves that even in the sixteenth century French girls could be witty and subtle and show it, and partly because another portrait of the same lady twenty years later (also attributed to Corneille) made me think of that devastating passage in *Les jeunes filles en fleur* which might stand motto to the whole Proustian comedy :

" Mais il suffit de voir à côté de ces jeunes filles leur mère ou leur tante, pour mesurer les distances que sous l'attraction interne d'un type généralement affreux ces traits auraient traversé dans moins de trente ans, jusqu'à l'heure du declin des régards, jusqu'à celle où le visage, passé tout entier au dessous de l'horizon, ne reçoit plus de lumière."

These sixteenth century portraitists carry on the old Franco-Flemish tradition. They are observant, penetrating, naturalistic, sincere and in excellent taste : also their style is the style of the miniaturists. Once

again we see men working within the limits
of their capacity, with something to say—
well-observed facts at least, at most psycho-
logical discoveries—and a gift for saying
it quietly and distinctly. They are at the
very antipodes of those Fontainebleau rhe-
toricians, with nothing of their own to say
and a half understood idiom in which to say
it. They are good draughtsmen, but never
quite great artists I think ; though I would
ask to be allowed to keep an open mind
about the elder Clouet, with whose most
significant work it appears I am still
unacquainted. Certainly if you compare
a random collection of these French sixteenth
century drawings with those of some
academic professor who has aimed at the
same mark, with those of Legros or Professor
Rothenstein for instance, or even with the
pastels of La Tour, you will realise that they
are remarkably good ; but the moment you
compare them with the drawings of a great
artist, of Ingres say, you perceive that they
lack passion and depth, that the line states
a fact instead of creating a three-dimensional
form.

This sixteenth century tradition is carried honourably into the seventeenth by the Quesnels—but not by Callot, who was a stylish prestidigitator. And I think, though I am not quite sure, that the Le Nain also may be counted continuators. They are contemporaries of Poussin, but their art and spirit, in so far as they are specifically French, are of an earlier day ; so perhaps I may say here what I have to say about them. Formerly the brothers composed a Trinity, the persons of which appeared inextricably confounded : but scholars, and notably M. Paul Jamot, have lately been at work on the plexus, and now we must recognise three distinct members, Antoine (1588–1648), Louis (1593–1648) and Mathieu (1607–1677). To give them temporal habitations and names is one thing, to distinguish the contribution of each to the common stock quite another ; again it is a matter of scholarship, and I a sciolist. If I am right in supposing that the *Famille de paysans* (no. 3113 in the Louvre) is by Louis, I shall venture to opine that Louis was the most gifted of the three. Bearing

*PLATE XIII*

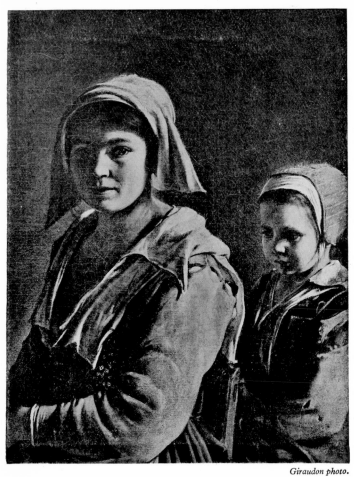

*Giraudon photo.*

Le Nain                    Famille de paysans (détail)

in mind that the Le Nains came from the extreme north of France, and knowing something about what happened in the adjacent Low Countries during the late sixteenth and early seventeenth century, I was never much surprised by signs of Spanish influence in their work. There is a realism in their still life which is not the humane naturalism of France and Flanders, but makes me think, wrongly may be, of Velasquez. Also from their human beings emanates sometimes a whiff of sentimentality which recalls Murillo ; and this, since Murillo was not born till 1617, is odd, to say the least of it. However, it is not quite impossible that the Le Nains should have been influenced in their latest work by Murillo, and now it comes out that Mathieu —who some people think was the one who painted the good pictures—made a pilgrimage to Rome and was there with Velasquez. If scholars consider this the more likely explanation of the unmistakably Spanish flavour in the work of one at any rate of these Picards, it is to be presumed that it is the more

likely.[1] Anyhow the scholars are now all a-buzz about the brothers Le Nain, thus paying the homage that science owes to art. For it was the painters who brought them into fashion, and prominent amongst painters the Professor Lhôte. M. Lhôte, I seem to remember, praised especially the content of their pictures. The Le Nain peasants he commended as modest, respectful and dependent, which in these days of Bolshevism is of course something. Nevertheless, I think there is more than that to be said for them —for the pictures, I mean. Their strange colour, cold and slatey, something quite new in French painting, still takes us by surprise. The traditional French naturalism, sympathetic observation truly rendered, is here mixed with a profounder realism, that agonised passion for the fact which at its intensest thrills us in Velasquez. Here, we feel, is something rare if not magnificent. Against this must be set the unfortunate

[1] And then what is to be thought of the so-called Le Nain of Rheims, with its Italianisms and reminiscences of Rubens? Was there one brother who composed always in the manner of the masters and had nothing of the village photographer about him? I must leave it to the scholars.

fact that one at any rate of the brothers has
no subtler sense of design than the village
photographer who ranges the wedding guests
in a row and invites them to fix their eyes on
the camera whence a little bird is about to
pop. Moreover, sometimes the little bird does
not ; and then, if the composition reminds
us of a group that has been told to keep
still, the figures remind us of " cinema "
actors who have been told to register
emotion. I sometimes wonder whether the
Le Nains were quite so sincere as the critics
would have us believe. Be that as it may,
their pictures have the merits of originality,
arresting colour, and sometimes a startling
realism, for which, after wading through the
sixteenth century, one is perhaps unduly
grateful. Anyhow, provided the organisers
of the exhibition are not going to work
themselves up too much about these God's
good men, I, for my part, am prepared to
like them a good deal.

Poussin was born in 1594, and the earliest
indisputable work of his that we possess is
dated 1630. In 1577 was born Rubens.
Since then great painters have lived, worked,

and left their mark ; the East has been discovered and the Middle Ages ; classical antiquity has been rediscovered ; the French temperament has persisted : but, speaking very generally, as indeed one must in an essay, I think it is true to say that Rubens and Poussin are the fountain and origin of the French tradition. Naturally the influence of Rubens has been the more potent ; he was the greater man. He is the grand master, not of the French school only, but of all modern painting. If you care to go to the Wallace collection and take another look at the landscape in the big room, first you will be rewarded with that sense of glorious satisfaction which only great works of art can give, and later, if you will let your eye rest on the right-hand bottom corner, you will be held by some ducks feeding on the edge of a puddle amongst weeds and rushes and foliage. In the sumptuous rendering of these beautifully observed facts you will, without an effort of pedantry or ingenuity, become aware of the springs of modern painting ; for inevitably you will find yourself remem-

bering passages that have charmed you in Watteau, Boucher, Fragonard, Gainsborough and Constable, who lead you on simply enough to Delacroix, Courbet and Renoir. Possessed of an inventive genius greater perhaps than that of any man who ever expressed himself in paint, of vision unsurpassed in its acuity, and of a sense of reality, not as we perceive it normally but as we perceive it in our most brilliant moments, Rubens possessed also—this is the miracle—powers of execution equal to his genius. So whenever we enjoy a Watteau, a Fragonard, or one of those marvellous overground Chardins — those luminous, lovely, and all too rare portraits of girls for instance ; whenever we linger greedily over a bit of eighteenth century decoration ; whenever we revel in the broken paint, the happy juxtapositions, the lovely smears of Constable or Courbet ; whenever we are fascinated by the rapidity of Tiepolo, or the fine frenzy of Turner, or the glorious luminosity of Renoir, or the violent tastefulness of Matisse, let us thank God for Rubens. His miracles are enough to

make anyone believe that the brush can inspire the mind. But when we have been seduced to acquiescence in that heresy, it is time to turn sharp round and look at Poussin. No question here but what the mind controls and conditions every stroke of the brush. So, when we have noticed that the great French painters in their most daring idiosyncrasies still subject temperament to an acquired logic, that they respect the principles of formal construction and live by a rational faith in tradition, let us remember to be thankful that at long last, at the third attempt, in 1624 to be exact, Poussin found his way to Rome.

*PLATE XIV*

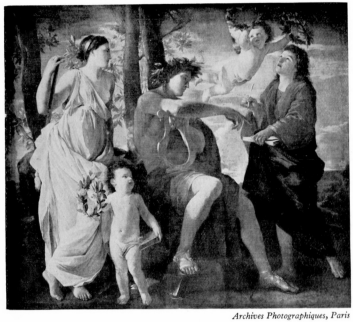

*Archives Photographiques, Paris*

Poussin                                    Inspiration du Poète

## TRADITIONAL

ABOVE those flowery plains and fruitful hillocks so far traversed, we have seen standing high the Avignonnais. They alone, in a world of men who describe with sensibility things acutely seen, are passionately expressive. So far we have seen nothing to equal the *Pietà* ; now we are going to meet its match. Poussin's *Inspiration du Poète* is of the same world : it is passionate and expressive, though the passion is concealed and the expression has been achieved laboriously, one might say scientifically almost. Poussin is an eclectic. The lords of the high Renaissance (Raphael, Michel Angelo), the Bolognese (Caracci and Domenichino), the Venetians (Titian and happily and most surprisingly Giovanni Bellini), classical sculpture, all contribute to his art. And do not suppose that they were contributory merely as Rubens was to the colourists of the eighteenth and nineteenth century ; to Poussin they were not

inspiration only but models. Like other eclectics, he believed that by taking thought and studying the masters intelligently one could extract from each peculiar beauties, the sum of which, combined in a single picture, must logically amount to perfection. And not only did he pray in aid what he considered the masterpieces of visual art, he went to the approved authors as well, and always with one end in view—perfection. His life and work are the flat contradiction of every gallant rebel who has inveighed against the habit of leaning on the past ; but it is a mistake to suppose they give reason to every professor who holds that, by reverently studying the masters and attending to what the professor says, a student can learn to make a work of art. Those good men the Caracci stuck to the rules as tightly as Poussin, studied as intelligently and as diligently, yet never produced anything one would dream of comparing with the *Pietà* of Avignon. What Poussin possesses and the academicians lack is the breath of individual genius.

He is always himself, and that self is an

elegiac poet blest with a divine gift of plastic expression. He learnt from the great Italians of the sixteenth century what the Italians of his own age could not learn, because he understood them as the Italians of his age could not. If he believed in rules, those rules had been proved by personal experience. If he affected pyramidal construction, if he raised human form and gesture to heroic scale, if he never put all his figures on one plane, if he contrasted movements, it was because, whatever he may have said or believed, that way his genius lay. His art is classical in the sense that it makes no pretence to represent life. Those monumental groups are not supposed to be probable, to be the sort of thing you meet in the street or on a country ramble ; they are intended to be equivalents of a profound emotion, and that is what they are. As he grew older the emotion changed ; beginning as an ardent and lyrical reaction to beauty (Marini, introducing the young painter to the Cardinal Barberini, writes : "vedrete un giovane che a un furia di diavolo"), it became meditative and tinged with melancholy.

But always the rendering kept step with the change : always the colour is exquisitely harmonious and personal, always the line beautifully nervous, always the composition—to the superficial eye conventional—quietly expressive. Poussin is never dry, unless it be a little towards the end, when the poet is fading into the philosopher ; the man who said that " les belles collomnes de la maison quarée " made him think of Italian peasant girls was not very likely to be dry. He was scholarly and thoughtful always, and when he painted such pictures as *L'Inspiration* and *Echo et Narcisse*—the *Comus* and *Lycidas* of this mute Milton—he was exquisitely lyrical as well. Later, grown graver, he found in Roman ruins sympathetic forms, and paradoxically painted them, these memorials of a vanished greatness, as though the system of which he was part would last for ever. Poussin is one of the very great painters. Were I commissioned to make out an honours list of European artists I should not put him in the first division of the first class beside Giotto, Piero della Francesca, Raphael,

Rubens and one or two more ; I should not give him a 1 (1) but a 1 (2). May I point out in passing, for I think it significant, that the two indisputably first-rate French painters of the age, Poussin and Claude, both spent their working lives in Rome. It is not the fact that they lived in Rome that signifies, but the fact that they kept clear of the Louvre and Versailles.

When Poussin went to Rome only two courses appeared open to a young painter arriving in the artistic capital of Europe— to join the school or ape Caravaggio. For, though Raphael, Correggio, and the Venetians were the gods, either Anibal Caracci or Caravaggio was the master. True, both had been dead these fifteen years ; but their spirits marched on, one in the school, the other in what was absurdly called "Naturalism." Between these a young painter had to choose ; and had Poussin been less sensible and less sincere, had he been seduced by the meretricious qualities of Caravaggio, the history of French painting might have been different.

Caravaggio was one of those men to be

found in all climes and ages who, endowed
with talent—great talent sometimes—and all
the qualities necessary to winning applause,
lack entirely those which distinguish artists
from conjurers ; who, further and far more
strangely, endowed with ambition, audacity,
and a shrewd notion of how to get into the
limelight, perceive that one can turn a
knack for " doing " as well to doing what
happens to be considered important as
what is considered trivial. Herein lies their
singularity ; they perceive that the gifts
which make an immensely prosperous but
comparatively insignificant cheap-jack or
advocate will as easily make an infinitely
honourable rebel or a famous prophet, and
preferring glory to cash more often than not
get both. Inevitably, only a very few of
them are remembered, for they are of a race
ideally designed to be admired and forgotten.
Caravaggio, with his extraordinary gift for
creating illusions and advertising them, is the
most eminent of the tribe ; Carlyle and Zola
are possible runners-up ; Keyserling and
Joyce are the best examples in the present, the
age that is always theirs. Instead of remain-

ing useful journeymen, minor poets, story-tellers, likeness-catchers, West-end playwrights and reporters, they become apostles and innovators ; instead of remaining Friths they become Futurists. With their rebellious or prophetic airs they impress the more thoughtless of the very young. When they are perceived to be mere Royal Academicians in wolves' clothing the young like them less ; on the other hand, the old like them more. Lord and master, the most gifted of a gifted race, stands Caravaggio ; and when Poussin reached Rome his brilliantly impressive melodrama was still the rage. The young, including the young French—Valentin, Vignon —were his humble, or rather arrogant, servants. It could hardly have been otherwise. Whom else should they ape ? The school, though respectable, was so feeble and uninspiring that a lad of mettle could not be expected to subscribe to its anæmic articles. It was part of the achievement of Poussin, trifling when compared with the works he created, vast when historically considered, that he gave new life to a decent but moribund tradition, thereby

begetting French as opposed to Italian classicism.

Classicism, as we have seen, took root in France long before Poussin ; but it was not French classicism as we know it, but the Italianate variety. This variety persisted as a flavour, and can be traced through Vouet and his followers well beyond the middle of the seventeenth century. Of these followers Perrier (1590–1656) and Lahire (1606–1656) were the most admired, but I propose to do nothing about them beyond saying that they were worthy descendants of Fontainebleau and worthy ancestors of a long line of *prix de Rome* winners. The most respectable French painters of the period (the first half of the seventeenth century), always excepting the two great Romans, were Philippe de Champaigne and the Le Nain, of whom I have already written, and Lesueur (1616–1655), of whom I must now write. But first let me reproduce a work by the independent Blanchard (1600–1638), a mysterious figure, in whom seems to have been mitigated to the verge of elimination the Vouet infection. Escaped from that magnifico's studio, he took

PLATE XV

Blanchard

Angélique et Médor

the Venetians and Flemings for masters, and was soon being called " le Titien français." This absurd title is significant only as showing that his defection from the Roman school was generally recognised. He died young, but judging by this picture[1] (which is in the Metropolitan museum of New York) and one or two others that I have seen, I surmise that " he was likely, had he been put on, to have proved " not " royally " but exceptionally. And that I think is as much as need be said of the school of Vouet. To be sure Lesueur, Lebrun, Bourdon and Mignard all came out of it, but they are all too personal to be treated as disciples.

Lesueur never left France and hardly left the Ile de France. This in the age of Vouet, Poussin and Lebrun amounts in itself to eccentricity. Since he came from Vouet's studio his earliest pictures have naturally a great deal of Vouet about them. Are not the earliest pictures of every painter like the pictures of someone else? One learns to

---

[1] A writer with a taste for singularity will not miss a chance of expressing gratitude to his publisher. Without the pertinacity and good humour of Mr. Brace, of Harcourt, Brace, Inc., I should never have come by this delightful photograph.

paint, as one learns to speak or form one's letters, by imitating, which is why an early Raphael is like a Perugino, or a picture by Picasso, just after he came to Paris, like a Lautrec. Only after he has learnt his lesson thoroughly can a painter be personal, and even then the chances are he will be influenced by half a dozen artists living or dead. Odd, is it not, observed Picasso the other day, that, whereas it is thought discreditable in a child to have no discoverable father, it is thought discreditable in a painter to have any parents at all. Anyhow Lesueur's early pictures are influenced by Vouet and some of his later are a little dull; but do not let that discourage you, for many are lovely and all are sincere. He seems to have been one of those simple-minded people —apparently simple-mindedness and talent live happily together in a painter—who feel no call whatever to move with the times. Primarily a religious painter, he took the Christian story and the legends of the Church quite seriously; in the spirit neither of Bossuet nor of Pascal, but rather of an Italian primitive. In style and colour, on the other hand,

PLATE XVI

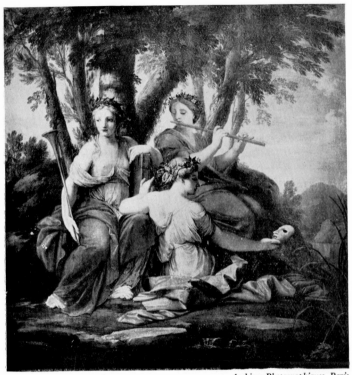

Le Sueur                    Melpomène, Erato, Polymnie

his profane works carry the mind forward to the eighteenth century and to Prud'hon even, and this although he died half a century before Watteau came to Paris. The fact is he was French rather than seventeenth century; and if you will look at those lovely decorations from the Hôtel Lambert, now in the Louvre, I am sure you will see what I mean. The subjects are classical: since they were painted in the seventeenth century what else should they be? Indeed the figure of Polyhymnia in a panel which I have not reproduced is altogether too classical, too declamatory, for my taste. The shell is classical—see how those pure profiles conform to the fashionable ideal of abstract beauty—but within all belongs to the world of Watteau and Renoir. Here is common life at its most delicious, seen with emotion and rendered with delight. These are no muses, but adorable French girls seen with the eyes of someone who is a little, but not passionately, in love with them. The silhouette may be respectfully antique; the colour, the painting of the flesh, have all the blonde luminosity of nature seen through a

temperament. The emotion is close to earth but just above it, the rendering direct and affectionate and as far from the methodical frigidity of the Caracci as from the rhetorical vulgarity of Caravaggio. In his profane art Lesueur is enchanting ; in his religious (*e.g.* in his scenes from the life of S. Bruno) sincere and adequate. I like to think he was a favourite with Monseigneur l'Archevêque de Cambrai.

After the reign of Vouet and his obsequious successors the official direction of art—for in the age of Louis XIV everything had to be directed officially—fell to Charles Lebrun (1619–1690). He was a decorator of talent and a man of boundless energy. He bores me. He believed in rules, in the wisdom of the ancients, in academies (l'Académie royale de la Peinture, founded 1648, l'Académie de France à Rome, 1666), he believed in himself and he believed in the State ; and we all know what the State was in the age of Louis XIV—*c'était moi*. Versailles is his monument, and Versailles bores me : not the gardens, Le Nôtre was a great artist, but the château without and within. Never has

the essential stodginess of the grand style so vividly appeared to me as one afternoon when, after taking my fill and something more of Lebrun and Coysevox and Girardon and the rest, I came suddenly, in the salon de Diane, on that tempestuous piece of virtuosity, the figure of the monarch himself by Bernini. It may not be a great or even a good work of art, but it is exciting. And for that, after half a day's boredom, I cannot tell you how grateful I felt.

Nothing pleased Lebrun better than laying down the law; it was his forte and for five-and-twenty years his profession. He laid it down according to the ancients as he understood them; but antiquity as understood by Lebrun was something very different from the sensitive and intelligent classicism of Poussin. Rather his academic discourses remind me of Davidian dogmatism, " le dessin est intellectuel, tandis que la couleur n'est que sensible." "Tout ce qui dans l'âme est passion, dans le corps est action," he proclaims, partly maybe to show that he has read Descartes, partly that his subordinates may know how to spread a little

butter over a very large slice of bread—the roof of a church for instance. That way lies rhetoric. At other times this master of the ceremonies decrees in the manner of the film-producer that particular modifications of the form of the mouth, nose, eyes and forehead shall register hate, joy, fear, "amour simple ou composé." That way lies le poncif—the stencil. Largillière in his portrait of the director accords him the Antinous and the Borghese gladiator as companions. Indeed this was a method of proving one's classicism much favoured by the Versaillais, who liked to see *les peintres du roi* distinguished by their attributes as though they had been saints or evangelists or God Almighty Him-self. So Largillière gave the master his appropriate bit of classical sculpture, while Mignard and Bourdon performed the kind office for themselves. But I have no wish to involve Sebastien Bourdon (1616–1671) in what on re-reading strikes me as an unduly peevish paragraph. Bourdon was an ele-gant eclectic who owed more to Lesueur and the Venetians, to Luini and the Dutch, than to Vouet and Lebrun.

Old Mignard (1610–1695) tottered on to the age of eighty without ever giving in to the tyrant completely (theoretically, I mean; in practice he could imitate him shamelessly), and at last, in 1690, succeeded him as *premier peintre du roi*. Poussin seems to have reckoned Mignard the best of the official bunch; at least, Mignardistes may take what comfort they can from this extract from a letter (dated 1648) to Chantelou: "J'aurais déjà fait faire mon portrait [eventually he made it himself and it hangs in the Louvre] puisque vous le desirez, mais il me fâché de dépenser une dizaine de pistoles pour une tête de la façon de M. Mignard, qui est celui qui les fait le mieux, quoiqu'elles soient froides, fardées, sans force ni vigueur." The criticism is perhaps too harsh: at the moment Poussin was out of humour with everyone and everything in Paris, having recently shaken the dust of that city, and especially of the Louvre, with its gang of official intriguers, off his feet for ever. But truly there is not much to be said for Mignard, except that, with the aid of his pretty models, he

gave the French language a pretty word—
*mignarde*.[1]

So let us return to Rome and the two
great French painters of the age. Claude
established himself there as a painter in
1627, but earlier he had tried his luck as
a cook, a fact which goes to support one of
my pet theories, that painting and cooking
are kindred arts. That Claude should not
have known Poussin, who had arrived three
years before, seems almost impossible ; yet
there is not a scrap of evidence to show
that he did. Experts, to be sure, can dis-
cover the influence of Claude in Poussin's
landscapes—which, by the way, proves
nothing more than that Poussin had seen
Claude's pictures—but that sort of detective
work is beyond me. As I have said and
must repeat, I am no scholar, and that
Claude influenced Poussin or Poussin Claude,
is a notion that could never have entered
my mind unaided, and which, I must add,
having been pushed in, finds no welcome.
On the other hand, I can discover reasons
for their never having met, if in fact

[1] At least so says M. Pierre Marcel ; Larousse thinks otherwise.

they did not. In the first place, you must remember that Claude was a German; that is to say, he came from Lorraine, which when he was born was part of the Empire. He was hardly ever in France, and it is far from certain that he could speak the language fluently. Write it tolerably he could not ; but that proves nothing, seeing that he could write nothing tolerably : he was illiterate. Anyhow, it is noteworthy that his great friend—" copain " is the word here indicated—and biographer was Sandrart of Frankfort, and that at Rome he is known to have lived amongst Germans and Flemings. Shop apart, what would he and Poussin have had to talk about ? Also, the grave Poussin, deep in literature, philosophy, and archaeology ; Poussin the melancholy, the distinguished and—it follows from the rest— the disdainful, would, I suspect, have tended to avoid the society of professionals and artisans whose job happened to be paint-ing pictures instead of painting houses : for such Claude and the jolly German students, his companions, must have appeared. " Il signore Poussin "—said

Bernini, tapping his forehead—" è un pittore che lavora di là." Claude did not even labour from where Renoir said one should : his inspiration appears to have come from somewhere between the two. Outside his trade he was totally uneducated and incurious, and even in his craft he was not accomplished. Again, though I do not know what Poussin would have thought of a man who could not draw the figures in his own compositions but had to employ hacks for the purpose, I surmise it would have been something to discourage intimacy : and remember, to express his thoughts Poussin had a tongue which was ever at the service of those whom he despised. Inevitably Claude reminds one of Corot. He was ignorant and stupid, which means that the moment he lost hold of what he understood he became silly. He was unworldly. He cared for nothing but painting—and his friends, you may add, if you like to suppose so. Nevertheless he was a master.

Corot learnt much from Claude ; indeed it may have been Claude's example that saved him from becoming a mere Barbi-

zonian, just as the example of Poussin may have joined with the spirit of a scholarly age to save Claude from becoming a Turner. Living when and where he did, he could not but feel that an artist has more to do with his sensations than jot them down higgledy-piggledy. He was the first great artist to apply himself wholly to landscape ; he could no other, for only in landscape could he express himself. He could not draw his own figures ; so by reason of his limitations he became a specialist, the first professional landscape painter of the French school. The hero of all his works is the sun, so it is hardly necessary to say that the Impressionists owe him much. But living when he did, he could not take light as it came : light had to be organised into form. That is his achievement : these hymns to sun and air have the classical solidity of Poussins. Turner got it into his conceited old head that he could do better, and insisted on having a picture of his hung next a Claude in the National Gallery. The contrast is instructive. The Victorian poet— for Turner was a poet too—has got the

pieces but cannot put the puzzle together ; and that was just what Claude could do. He could build in light and atmosphere. Atmosphere I say, because Claude, who in some ways was Flemish rather than Italianate, saw the sun of Italy through northern eyes, shrouded in mist and rack. That was the stuff out of which he wrought,

" The cloud-capped towers, the gorgeous palaces,
   The solemn temples,"

which, unlike Prospero's insubstantial pageant, were caught and solidified in enduring form.

The most serious charge that can be brought against Claude, and a serious one it is, is that he repeats his effects, and so repeating slips into *le poncif*—I use the French word because it is more elastic than stereotype or stencil. It is not easy to say the same thing over and over again and mean it every time : think of the parson reading morning prayers. Also *le poncif* is far more distressing, more apparent that is, when employed by a stupid than when employed by a clever man : the clever

Claude         Marriage of Isaac and Rebecca

being clever enough to cover up his tracks and hide his yawns. Amateurs have another grievance, which is no fault of the painter's however : it is that Claude's pictures have suffered more than most from the barrels of pea-soup varnish and dirt with which two and a half centuries of connoisseurship has thought to ennoble them. When this mantle of respectability is removed the colour is generally found to be lovely and, what is worse, lively. Thus connoisseurs are confronted by the surprising fact, by which none but a connoisseur could be surprised, that old masters and new are very much alike, or at any rate that neither are like what connoisseurs could wish them to be. So far as possible those in power and possession prevent this unpalatable truth leaking out by keeping their old pictures locked up behind walls of filth. It would be more sensible to keep them locked up in strong-boxes, with the names and dates of the artists on the lid and the prices paid for them, and I make no doubt that is what many directors of galleries would prefer. By cleaning pictures you run a risk of

damaging them, say the pundits, and for pretty obvious reasons a certain number of dealers say ditto. Very true, you run a risk : and you have to choose between taking that risk, a risk that will enable you to see something at any rate of what the artist painted (almost as great a risk), and gazing for ever at a blank wall. Which do you prefer, the picture, or at least a good part of the picture, the artist painted, or the venerable muck of ages ? Years ago the more intelligent directors of German galleries, and in England Sir Charles Holmes, decided that they preferred the artist's version, and got into trouble accordingly. Nevertheless, so far as they dared they persisted ; and Dr. Bode being a man who dared stand up to anyone, the Kaiser Friedrich museum now contains the best presented collection of pictures in Europe.

Claude's pictures in particular, seventeenth century canvases in general, have suffered exceptionally from the glue-pot, the reason being, I surmise, that they have passed through so many collections, through the hands of so many connoisseurs. Also

the private and public collections of England are exceptionally rich in Claudes and Poussins—prolific artists both. If only owners and directors, who have a way of behaving as though they too were owners, would take a hint from Germany, what pleasant surprises Burlington House might have in store for us.

One never knows where one may not come across a picture by Rigaud (1659–1743) or Largillière (1656–1746) ; sometimes it will be hanging amongst the grave masterpieces of the grand siècle, sometimes in the eighteenth century room, and some-times amongst the furniture : this is because Rigaud and Largillière belong to the transi-tion. Transitions are awkward but undeni-able phenomena which take half the fun out of history ; painters and writers should die off with the king or century, or change their style at least. As they will not, styles are always running in and out of each other. Positively, at one moment, about 1765, things came to such a pass that you might have seen pictures which any

modern, chronologically-minded *Kunstforscher*
would distinguish as "seventeenth century,"
"regency," "Louis XVI," and "consulate,"
all hanging in the same salon. The transi-
tion from seventeenth to eighteenth century
is better defined than many ; memorable
events do synchronise to some extent with
appreciable differences. Thus 1690, the
death of Lebrun, is a date. From that year
forth any hitherto repressed subject who
had anything of his own to say should have
dared to say it ; and sure enough Rigaud and
Largillière, both of whom had something—
not much—of their own to say, begin now
to get names for independence. Both
had been touched by influences of which
Lebrun would have disapproved ; both to
some purpose had admired Rubens, and
Rigaud had looked at Rembrandt even.
He had been to England too, where from
Lely he learned to admire Van Dyck, and
where, as readers of Gramont—or rather
Hamilton—will remember, he painted a
portrait of the Middleton. After the death
of the tyrant, both Rigaud and Largillière
ventured to display their acquisitions. Un-

luckily neither had much to show. Rigaud is pompous (his full name was Hyacinthe-François-Mathias-Pierre-Martyr-André-Jean Rigau y Ros), and Largillière is a virtuoso. For my part I prefer virtuosity to pomposity. When in 1692 Antoine Coypel (1661–1722) exhibited his *Démocrite* it was reckoned, and rightly, since it is a frank imitation of Rubens, revolutionary. Amusing, is it not, to see the lists already set? Be it Lebrun or Ingres, he who stands for the school invokes the authority of Raphael and the ancients, while the revolutionary, Delacroix or Watteau, swears by Rubens. It is the age-long and idiotic battle between line and colour.

Antoine Coypel's *Démocrite* is sympto-matic ; but the distance covered between 1650 and the end of the century is best measured by comparing Poussin's *Discovery of Moses* with a picture of the same subject painted about 1700 by Charles de la Fosse (1636–1716). Both are in the Louvre, so the comparison is easily made. Evidently this M. de la Fosse, a pupil of Lebrun who was over sixty when he painted this piece

of pure dix-huitièmerie, was one who knew
how to suit his manners to his company :
his picture, influenced by Rubens and
Veronese, is as winningly naturalistic as he
can make it. It is a pretty thing meant to
please pleasure-loving people, and I think
I need not labour the contrast with Poussin's
grave composition. In 1704 Santerre (1658–
1717) painted his more famous and far
prettier *Suzanne*, that perfect essay in the
baroque S, dear to all amateurs of the style
and to me still charming. Here we have
rococo (for what is rococo but a suggestive
name for late baroque ?) unstiffened with
a single whalebone from Lebrun, and
without so much as a civil nod for the high
Roman taste. All that delights us in this
blonde, human arabesque, all, that is to say,
which is not due to the model, is due to
Rubens and Bernini. It is charming, gay,
aristocratic, and lascivious ; in short, it is
regency. But, though Santerre set up an
academy of painting for young ladies who
served him indifferently as models and
mistresses, the regency is not yet.

Two years earlier something had happened

*PLATE XVIII*

*Bulloz photo.*

Santerre

Suzanne

otherwise important than the painting of a rococo portrait of a pretty Parisienne : in 1702 Watteau had come to Paris. To Paris, mark you, not to Versailles : once again the capital is the centre of civilisation, so no wonder things are becoming livelier. The eighteenth century is coming to birth : the eighteenth century is born, but the age of Louis XIV is not yet dead. Neither is the eponymous monarch ; his death in 1715, with the consequent drawing of the Maintenon's teeth, is an event indeed. All over France goes up a sigh of relief which sounds oddly like a shout of joy : gone at last the old monster and the monstress ; now the eighteenth century can begin. Now we can be natural, now we can indulge our own tastes, now we can enjoy ourselves, putting on less uncomfortable clothes and flinging ourselves into positively comfortable chairs, chattering and romping in our own delightful rooms instead of shivering on parade in palaces : now we can taste *la douceur de vivre*. Nothing tells the story of the change better than the pictures : regency art, like romantic, is a reaction from the

static and official to the agitated and
intimate ; and if some painters try, as try
at times they will, to beat the big drum, if
Lemoyne (1688–1737) insists on making his
ceiling at Versailles grandiose, we can but
tell him charmingly that the result is a
manifest anachronism. For in the eighteenth
century the studied pomposity of a man of
talent even looks absurd. The art of Ver-
sailles was an art of public life ; under the
regent we live en petit comité. Against
Versailles the eighteenth century is in revolt,
and a good part of its vigour derives from
a passion for breaking those laws which
the seventeenth had laid down. For instance,
under pain of contempt and worse, seven-
teenth century painters had been expected
to hide those processes which go to the con-
fection of a picture ; the eighteenth glories
in the kitchen, displaying with esurient
complacency its condiments and utensils.
We revel in the sheer, sensual beauty of
lovely paint lovingly smeared. Also we—
we amateurs I mean—give our painters a
pretty free hand, requiring of them never-
theless, especially if we happen to be

amatrices, two things : (*a*) that in our portraits we shall be made to appear attractive and interesting ; (*b*) that our rooms shall be decorated. Essentially and above all eighteenth century painting is decorative ; and later ages have been unjust to many a picture of the period because, instead of seeing it in a panel over a door or between windows, set off by harmonious furniture, they have seen it in a bleak museum and a heavy gilt frame.

In the seventeenth century hardly was a French painter deemed qualified till he had graduated at Rome ; in the eighteenth the Italians themselves keep an eye on Paris. Venice flourished, an exquisite little thing apart, but Europe got her painting from France. In St. Petersburg, Stockholm, Vienna, and Madrid they were trying, not very successfully, to paint Largillières and Bouchers, Nattiers and Greuzes. Nevertheless it would be a mistake to suppose that this pervasive manner was French to the core, indigenous as was the painting of the nineteenth century. Rather it was a dish compounded of various and imported meats,

whereof the mixing, cooking and flavouring were native ; whereas in the nineteenth century the prime materials were the produce of France and smacked of her soil : only a spice or two came from abroad. But derivative though this eighteenth century style might be, it was bound to become dominant because in the eighteenth century there was but one civilisation for the whole continent of Europe, and that civilisation was French. Alongside lay England ; and England and France were the twin founts that kept the world supplied with ideas, sentiments and systems. Freely they gave and took to and from each other, wrangling the while ; but so far as painting proper goes the giving was almost all on one side. Certainly English painters did not get as much from the French as they got from the Italians, the Flemings and the Dutch ; but look at any early picture by Gainsborough, after all the greatest English painter of the age, and you will realise the greatness of the debt. Not till the very end of the century, till just before '89 I mean, do French portraitists, with their craze for the " en allée,"

begin to take tips from over the way. But
when we come to realise how much in the
later part of the century French painters
were influenced by books and fashionable
ideas, and how much those books and ideas
were influenced by the English writers, we
shall have to ask ourselves whether indirectly
the influence of English thought and feeling
on French painting was not considerable
and considerably to be deplored. Meanwhile
Paris supplies the Continent with culture :
it is at once factory and clearing-house.
Even English ideas have to pass through
Paris before they become European, and
Voltaire vulgarises Newton while all Europe
reads Richardson and Sterne in French
translations. It is Paris that imports, assimi-
lates, disseminates a fascinating cargo of
Eastern whimsicalities : turqueries, per-
saneries, singeries, lacquer, the "Arabian
Nights"—generically chinoiseries. And all,
from *Clarissa Harlowe* to *les magots des
Indes*, contribute to the flavouring of that
appetising dish which is eighteenth century
painting or, as I should prefer to call it,
decoration. Never have painters been more

open-minded or more catholic in their tastes. The age produced two masters, Watteau and Chardin, and a dozen painters of mark ; and if in dignity, depth of conception and splendour of performance it falls short of the grandest, let this—it is the summing up of M. Louis Gillet—be said and said at once : seldom have men painted better and never with less pedantry, declamation and pomposity.

Before trying to say my word about the eighteenth century painters there is one more observation I should like to make about the period in particular and French painting in general. Anyone blest with aesthetic sensibility, though he or she knew not one fact or legend about the painters or the subjects of their pictures, nothing of history, mythology, theology or hagiography, might have gone every day of the three months to the Italian exhibition at Burlington House and come home each evening with his or her capacity for aesthetic experience filled to overflowing. The supply of pure aesthetic ecstasy to be won from that marvellous array of pure masterpieces was

enough, and more than enough, to satisfy any spectator's capacity ; no place was left —supposing him or her truly sensitive to visual art—for any adventitious emotion. To get the most out of the French exhibition, to fill the cup of experience to the brim, more than pure aesthetic sensibility will be needed. But let no one be alarmed ; it is far commoner to possess a little of $x$ plus a good deal of $y$ than to possess $x$ to the $n$th. Thoroughly to appreciate a picture by Masaccio or Raphael, an acute and infinitely rare sensibility to form and colour in subtlest combination is essential. Thoroughly to appreciate a Boucher, some sensibility to form and colour is necessary, absolutely necessary, but that sensibility need not be of the kind that is as rare almost as creative genius and rarer than a first-rate intellect. On the other hand, to fill to the brim one's capacity for enjoyment with Boucher, one needs a little culture, one should be able to situate the picture in its artistic and social circumstances. And even when you have extracted all the aesthetic and quasi-aesthetic pleasure—and it is much—that

the picture can afford, still you will find room for a few additional drops, derived from your knowledge that the blunt little body and tip-tilted frimousse which haunt Boucher's pictures, which haunted his imagination even when the model was no longer there, pertain to La petite Murphy— *La petite Morphil* the Parisians called her— whom the Pompadour stole from the painter to satisfy the desires without possessing the will of Louis XV. And if you feel a little envious of the king you will still be within your rights, within the circle, I mean, of legitimate reactions to the picture. In a word, you will not get the best out of this exhibition, except in the nineteenth century room, unless you have a little particular knowledge and a good deal of general culture.

The French eighteenth century is the shortest in history, which will not surprise anyone who remembers that it was the most agreeable. Beginning in 1715, it ends in 1789, and, short as it is, falls into two parts, the frivolous and the earnest. The rebound from the Louis XIV–Maintenon oppression

lasted through the regency well on into the reign of Louis XV ; but by mid-century intelligent society was wearying, as it always does, of facile amusement, and between 1759 and 1762 France received a shock which gave momentum to the inevitable swing. Often enough before Minden and Quebec the French had got the worst of a war, but never before had they got quite so much of the worst in quite so short a time. In three years they lost an empire. Also seldom has defeat revealed so clearly that the whole political, economic and social structure of a state is in need of radical reform. Apparently the individual Frenchman, soldier, peasant, sailor, or artisan, was as brave, capable and enduring as ever, yet, thanks to generals and captains, politicians and administrators, to the system in fact and the laws, these virtues scarcely sufficed to keep his nose above water. Everyone could see that something was wrong ; every other one had a plan for putting it right. It became the obvious duty of decent Frenchmen to take things seriously, and taking things seriously meant taking the advice of the philosophers :

the philosophers being of course the novelists, pamphleteers and playwrights. Had they stood alone, these philosophers, the painters might have disregarded them ; but the cultivated rich, the patrons that is to say, were with them to a woman. So, willy-nilly, the painters must listen, with what results we shall see. The first to be noted is that, so far as painting goes, it is the first half of the century that is serious and the second that is frivolous.

The whole is dominated by Watteau. He was born at Valenciennes in 1684—by birth therefore a Walloon—and came to Paris in 1702 ; he died in 1721 at Nogent-sur-Marne of consumption. Someone—I think it was M. Paul Mantz, not a very good critic but right on occasions—has called him the posthumous pupil of Rubens ; and so, through Watteau, Rubens—Rubens the sensualist—inspires the age. Till near the end Poussinesque intellectualism is quite out of favour, and when at last it does return to fashion is completely misunderstood. Watteau's best pictures belong to that class of works of art which can properly be

described as miraculous. Miracles are notoriously hard to explain ; but as critics consider it their duty to explain the miracle of Watteau's art they generally say that he was a poet—only are not all great artists that?—who expressed a hitherto unexpressed emotion, an emotion for the gay and evanescent, or rather for the evanescence of the gay. I shall not presume to contradict ; only I must observe that had Watteau been no more than a man exquisitely sensitive to the frailty of beauty and the transience of garden parties he would not have been one of the greatest painters that ever lived. When I look at one of his masterpieces—there are three in the Wallace collection to begin with—I am bewildered by the marvellous beauty of each detail and by the way in which each heightens the beauty of the whole. One never gets to the end of a great Watteau. Honestly, I have tired myself out looking at a single picture. You think to concentrate on the figures in the foreground and your eye is carried to a basket of flowers in the middle distance, wherein each nosegay is as passionately drawn, as adorably painted, as the

protagonists of the piece. The basket, itself a miracle of painting, leads you on to couples —triumphs of nervous, excited drawing— strolling in the remote distance by a lake or between trees as acutely rendered and enticingly coloured as anything in the picture. Did you notice those two statues one on each side of the composition ? They have an air of being half-alive have they not ? Critics will tell you it is because for Watteau and his age classical art was a live thing, as it was not for David and the Davidians. I don't believe that : I believe the historical judgment is correct, but I do not believe it has anything to do with the matter in hand. If these statues are faintly and ironically alive, that is because the rigidity of marble would have disturbed the inexpressibly delicate rhythm of the picture, and, I admit, have jarred on the mood. For a mood there is, though I should be hard put to define it, and so would anyone.

> " She lives with Beauty—Beauty that must
> die :
> And Joy, whose hand is ever at his lips
> Bidding adieu. . . ."

PLATE XIX

Fête Galante (détail)

Watteau

No : that is too consciously pathetic. Perhaps the mood of an Elizabethan lyric comes nearer :

> " Sing thou smoothly with thy beauty's
> Silent music, either other
> Sweetly gracing."

Look at a drawing by Watteau ; look at this fragment. Nothing is posed ; everything has been seized with anxious rapidity. Possibly the anxiety was about the flight of time and man's ineluctable doom, but I suspect it was about the problem of discovering a line that would be the exact equivalent of a sensation. All is beauty and living beauty ; I mean the beauty of line and colour corresponds with, arises out of, a living movement. I will admit, if you please, that Watteau's pictures are the dream come true of a life better worth living than any that those of us who are neither poets nor happily in love can hope to live, if you will agree that what makes the miracle is that the representation consists of forms and colours, thrilling in every detail, exquisitely harmonious as wholes, and by their sheer

visual beauty bewitching. I do not know whether I have succeeded in conveying at all what a picture by Watteau makes me feel ; but if I have, I may hope to have given you something better worth your acceptance than a variation on the familiar theme—the poitrinaire at the picnic.

Watteau dominates the age ; all the big men, except Chardin, who is too big for any servitude, are to him in fee. Lancret (1690–1743), Pater (1695–1736), Lemoyne (1688–1737), Troy (1679–1752), Charles Coypel (1694–1752), Jean-Baptiste Van Loo (1684–1745), and Ollivier (1712–1784) are named when people speak of the school of Watteau, which, by the way, never existed, for, like Delacroix, he did not open his studio to pupils. Nattier, Boucher, and Fragonard, for all that they are heavily in his debt, are too personal to keep company with a crowd of followers ; while Desportes (1661–1743) and Oudry (1686–1755) stand apart. Desportes and Oudry may be considered together, notwithstanding that one is twenty-five years older than the other. Jointly they are responsible for introducing into French

painting something small but new—the exact and passionate observation and rendering of the minutiæ of nature. Such things as dogs and birds the older masters had treated broadly ; seeing them from a distance they had dealt with them as parts of the landscape, and even at close range had taken them very calmly. Later, the Impressionists were to observe nature acutely and passionately, but to treat it as a mode of light and movement. Desportes and Oudry were the first in France (Desportes was the pupil of Nicasius, in his turn pupil of Snyders) to paint the portrait of a particular dog, and even of a particular pheasant. Also they were the first to catch the movement of an animal and freeze it stiff. These dogs are not posed ; they are frozen dead in a natural gesture. How unlike is this sincere, enthusiastically observed, but tight drawing to the line of Watteau through which still flutters the stream of life. Oudry has other and perhaps stronger claims on our recollection ; he was one of the first painters to take a scientific interest in light. His academic discourse of 1749, in which he expatiates on the necessity of studying the

colour of objects by comparing one with
another, of painting a silver bowl with its
peculiar whites, and of colouring shadows,
still enjoys a mild celebrity amongst art-
historians.

Nattier (1685–1766), like all the rest,
learnt his trade of Rubens. He even made
drawings of the Medici series, then in the
Luxembourg and now in the Louvre.
Nevertheless he started shakily, as cricket
reporters say, with his mythological portraits
of reigning beauties, which are altogether too
stagey and conventional for my taste. But
Nattier developed : to develop and go on
developing is the mark of a genuine artist.
The mere professional with a knack will often
produce something worth stopping before
when he is young and enthusiastic and unset,
but the moment he has found his formula
down he settles to exploit it and soon be-
comes successful and insignificant ; whereas
the genuine artist goes on discovering him-
self and the world so long as he can hold
a brush. It was about 1740 that Nattier
bade farewell to Olympus, and some fifteen
years later he painted those portraits of *Les*

*Mesdames* which are about the most agreeable things in the palace of Versailles. They are lovely, and when one remembers that the daughters of Louis XV were not only ugly but ill-tempered, our admiration for the artist increases. Nattier came under the influence of Gillot (1673–1722), the scene-painter and theatrical designer, who had the honour of being the corporeal master of Watteau. Very few works by Gillot remain, and those reveal him nothing better than an illustrator : his importance is considerable however. Through him Watteau, and through Watteau the eighteenth century painters, came under the spell of the theatre. The connection was on the whole beneficial. Everyone has noticed that the people in eighteenth century genre-pieces—especially in those of the first half, the *fêtes-galantes* period—have an air of being on the stage, and that the background has often the look of a backcloth. Michelet, and sillier than he after him, have taken this for a characteristic of a frivolous age, not failing to draw the appropriate moral, whereas, in fact, it is a sign of the influence of Watteau. Talking of

the influence of Watteau, may I observe that
it was that of a lover, not of a schoolmaster,
infectious not didactic. Lancret and Pater
alone received direct instruction. Lancret
was an excellent painter and a sagacious
critic, Pater not much more than an ape.

Boucher is the link and pivot of the century.
At its crucial moment (about 1762) he was
at the height of his influence and therefore,
naturally, past his prime ; and it is at this
moment we can see him plainly enough
joining hands with Watteau and Fragonard.
But before talking about Boucher, let us take
a look at the two portraitists La Tour (1704–
1788) and Perronneau (1715–1783). La
Tour, the pastellist, was and still is bound-
lessly admired. He went the right way
about it. To command present fame and
future immortality there is nothing like being
in with the writers. Also the alliance is often
fortunate ; Thackeray and Baudelaire dis-
covered Guys, Zola wrote up Manet, and it
was the writers who opened the eyes of the
public to the beauties of the Impressionists
and Post-Impressionists. La Tour is claimed
as the carrier-on of the French tradition of

portraiture, the tradition of Clouet ; he is described as a social historian and psychologist—both titles to literary fame, be it noted. An observer of contemporary life he certainly was ; and if some of us do not rate him high as a psychologist it is not because he lacked the pretention. Shamelessly he underscored every trait that could be considered soul-revealing ; indeed he so accentuated the signs of the ruling passion, or what he took for them, that more often than not we quite lose the model in the effect. Like many vociferous painters, who have pushed in with the missionaries of a social, political, or religious movement, he was taken by his friends pretty much at his own valuation. How else should propagandists and politicians, who know nothing about the visual arts, take a painter or sculptor who professes to preach their doctrine in his mysterious, concrete medium ? He seems to stand for all that is manly and downright in a movement : a Morris amongst the Socialists. Although La Tour's art, brilliant and telling at times, is about as cheap and flashy as anything that could possibly be called art

can be, Diderot and Rousseau, for once of a mind, agree in admiring hugely its obvious psychological strokes and merciless emphasis. This, I think, is the first time I have had occasion to mention Diderot, philosopher, reformer, and critic. It will not be the last. In their appreciation of the visual arts he and that other world-improver, Tolstoy, make an exemplary pair.

Perronneau shows up neatly the more glaring vices of La Tour. Where La Tour has tricks he has art. At the point where La Tour rides off on his psychological broomstick, Perronneau begins to look more intently at the head of his sitter with a view to discovering some subtler delicacy of modelling, some more recondite relation of tone. Perronneau is a painter, La Tour is a physiognomist. Instead of knocking the model about till he or she screams, or tickling till he or she roars, and taking the ejaculation, whatever it may be, for the authentic expression of the soul, Perronneau digs deeper and ever deeper into what he sees. Here is one who keeps his eye on the object. Although he owes as much to Rembrandt as to Rubens,

he takes his place in the genuine French
tradition, the tradition of Fouquet and
Cézanne. Perronneau is a considerable
painter.

François Boucher (1703–1770) used to get
a bad press because he shocked the press-
men ; and I can only suppose that modern
critics, having heard from their uncles that
he was bad, have never looked to see what
their uncles meant by the epithet. It is quite
true that Boucher's pictures are generally
inspired by lust and are often intended to
provoke it, and that is not the worst that can
be said of them. The worst of Boucher is
that " il faisait du chic," that is to say,
instead of keeping his eye on the object he
painted what he thought should be there—
just as they are, or were, taught to do at the
Slade. There remains more to be said,
however. Boucher was a decorator ; few
have known better how to fill a given space.
And as the art of decoration consists in filling
given spaces, I have contrived to say, with-
out ostentatiously looking for trouble, that
Boucher was one of the great. Furthermore,
he was deliciously gifted and he is never

stupid. Few painters have been able to throw on to a panel three girls and a cloud, or three girls sprawling across a cloud, with such certainty of effect and so much grace. His colour is not only delicious, it is witty. So is his drawing sometimes. The witty impertinence of la petite Morphil's attitudes is matched by the witty woolliness of the sheep she so often tends. A room decorated by Boucher is one of those rare things that give the human race some right to be pleased with itself; for it is a complex of subtle human qualities intelligently blended and exercised. Diderot is beside himself with indignation, going so far as to complain that you will never find in a picture by Boucher children engaged on any profitable task, such as learning lessons or picking oakum. Some of us, of course, prefer to see children enjoying themselves. Anyhow Renoir adored Boucher.

And now I must do my best to say something sensible about Watteau's sole peer in the history of eighteenth century painting, one of the great painters of all time. That said, I hope, aided by my turn for generalisa-

Boucher           La Petite Morphil

tion, to dispose pretty smartly of the second, the serious or, if you choose to look with the eyes of Renoir rather than Diderot, the frivolous part of the century. For till 1762 or thereabouts most French painters had tried to paint ; but after 1762 it was thought more proper by many to try to make the world a better place. Now in my opinion, and Renoir's, when a painter ceases to be a painter he becomes ridiculous. Painters have done a great deal for the good of mankind, but they have done it by painting good pictures, not by painting bad ones ; and unfortunately, when painters have tried to do anything more than paint—well, they have generally succeeded in painting ill. To do more than paint as well as he was able was a notion that never crossed the mind of Jean-Baptiste-Siméon Chardin (1699–1779). " C'est bien bon de la bonne peinture " was his contribution to the thought of the century. His life almost spans it, but his work stands outside, though it could have been produced in no other. It could have been produced in no other because it sets the crown and pinnacle on the Dutch genre-painting of the

seventeenth and early eighteenth century, deriving through that mediocre Fleming David Teniers (1610–1690) from the masterly Brouwer (1606–1638). You will be glad to hear that Diderot found time to observe that he would give ten Chardins—or could it have been Watteaus?—for one Teniers.

Yet Chardin taught his lesson, though it was beyond the reach of the philosophers and their pets. He has taught decent painters, once and for all and all the world over, not to bother about "subject." He lived amongst simple things and people, equally unlike the marbles, brocades and aristocrats of Versailles and the virtuous opera-comical peasants of Greuze ; he stared at them with passion and was astonished by what he saw. Intimate as he became with his surroundings he never got over this astonishment. He was in love. Could the world really be so full of such wonderful things ? Was the visible universe, the interior for instance of an exceptionally dark scullery, really thus packed with miracles of beauty ? He must tell someone about it. Luckily he had brushes and a paint-box wherewith to tell,

*PLATE XXI*

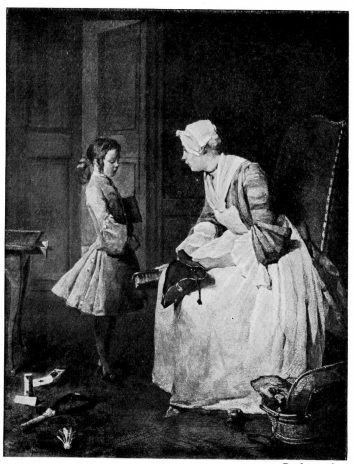

Chardin

Intérieur

and they were all he needed. He lived amongst simple things but he stared at them with passion ; he stared at a skate hanging by the nose and saw in it what Rembrandt saw in a flayed ox hanging by the hind legs : he saw all the splendour and glory of matter. He lived amongst simple people ; but a small shopkeeper and her family sitting down to lunch afforded as thrilling a revelation of forms in space as was vouchsafed to Velasquez when he surprised the royal children at play. Not suddenly, like Velasquez, but gradually he discovered the miracles performed by light, and he rendered them with a super-realism equal to that of the Spanish master. Chardin knew his way about the marvellous world he inhabited ; not only was he familiar with all the forms that changed and shifted in that minute segment of light, he was familiar with their relations to each other ; and when he painted them he painted not what I see, not what Tom, Dick or Harry sees, but what he saw. If ever painter kept his eye on the object it was Chardin ; he painted nothing that was not there, but what was there was his vision.

And vision more delicate, more acute, closer to the very essence of the fact and the very essence of relations between facts has never fallen to the lot of painter. Greatest miracle of all—the ever-recurring miracle of the master-painter—he had a hand to serve his eye. By exhausting his rich resources, his power of rendering in paint the indescribable subtleties of his vision and his emotion for that vision, he said, without any auxiliary flourish or air of mystery or impressive pause, precisely what he had to say. The result of this pure painting is pure beauty, and one can hardly avoid becoming silly about it. One is foolishly moved by the thought of this little old bourgeois, enjoying his dinner, placing his joke, petting his cat, going about his worldly affairs with scrupulous honesty and exactitude, disdaining success but delighting in a compliment, standing up for the young and deprecating harshness, sticking to his cronies and his quarter, and painting Chardins. Me, at any rate, it touches more than any story of frustrated genius or resonant success. But there is not the slightest reason why it should.

Having now said my say about the first, the *fêtes-galantes*, half of the century, I should like to put the second under the protection of Diderot and Greuze and be done with it. That would be neat and logical ; but unfortunately the development of the history of painting has already ceased to be neat, though logical it still may be. From this forward, if not from a great while earlier, it is useless to attempt making schools and movements succeed one another in chronological order, each occupying methodically its appointed portion of time. Henceforth, except for a moment under the Davidian dictatorship, all manner of schools and tendencies have to live together as best they can, which generally is very ill : henceforth there are exceptions to every rule. One reason for this troublesome confusion is that painters are now become completely individual, more consciously so in fact than most of their fellow beings, and therefore will no longer conform to a common doctrine. So long as, like masons more or less, they worked in a convention, according to a tradition imposed from above and accepted by all,

there was some sense in chronological classifications. In architecture " fourteenth century " means something definite ; for in the fourteenth century no French architect, all bursting with personality though he might be, took it into his head to build a Romanesque cathedral or a Greek temple. In Italian painting the Giottesque period, from Giotto to Masaccio, is only a little less homogeneous : by " trecento " we do mean something fairly definite. But when someone begins to talk about " eighteenth century painting," especially if he talks about " later eighteenth century painting," we find ourselves inquiring, even though he has spoken without the slightest wish to annoy—" Which kind of later eighteenth century painting are you talking about ? " Conscious individuality chiefly is responsible for this untidy diversity of tendencies : besides, we know too much. If we knew as much about what the builders and painters of the fourteenth century thought and felt and said amongst themselves as we know about the prejudices and crazes of the eighteenth, maybe those earlier periods would begin to seem rather less of a

piece than they can be made to appear by ingenious historians.

One thing is clear—the general direction given to painting in the later eighteenth century was not given by painters : it was imposed through society by the writers. They it was who started the craze for uplift, the patrons took it up and the painters followed. Of this movement unquestionably the most reputable manifestation was the passion for antiquity ; for this in part was a painters' movement, the painters being naturally and rightly excited by the discoveries at Pompeii and Herculaneum. Yet antiquarianism was not without its uplifting quality too ; seeing that, as every schoolboy had to know, the Greeks and Romans were models of civic virtue. As early as 1763 Grimm writes, " tout maintenant est à la grecque." When antiquarianism meant no more than attiring ladies in chiton and himation and painting sentimental portraits of them thus tricked out, or manufacturing in the reign of Louis XVI furniture vaguely reminiscent of Louis XIV, there is nothing to be said for it. It is merely a manifestation of

the prevalent taste for things virtuous and heroic. But we ought in justice to remember that eighteenth century neo-classicism produced David (1748–1825), a great figure after all, of whom, before we have done, more, much more, must be said. Also it produced Hubert-Robert (1733–1808), who was at very least a delightful decorator; and Joseph Vernet (1714–1819), whom Rome sent to school with Claude, and who in early days was something of an artist, though later, to suit the fashion, he became instructive and insincere. We ought to distinguish between those anecdotists who painted ruins and scenes from ancient history because in them they found material for profitable lessons and popular moralising, and the painters who saw in them only new and stimulating motives for pictures.

Meanwhile the tradition of the regency was kept alive in the studios of a few genuine painters, who paid as little attention as possible to the philosophic chatter of their contemporaries. Of these Fragonard (1732–1806), who to save his neck was obliged before the end to pay considerable attention to the chatter of his pupil David, was of

PLATE XXII

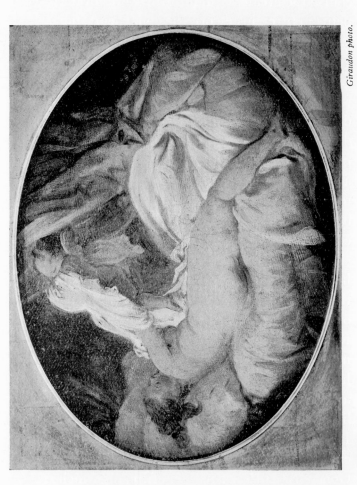

Fragonard

La Chemise Enlevée

course the greatest. But in the works of the petits maîtres, his escort, the gouacheurs, the engravers, Gabriel St. Aubin (1724–1780) and his brother Augustin (1736–1807), Lawreince (1737–1807), Moreau le jeune (1741–1814), Eisen (1720–1778), and Baudoin who married Boucher's daughter and died untimely (1723–1769), you will find plenty to please and amuse. Fragonard was a meridional of prodigious versatility and temperament. For all his versatility and infectibility one cannot well call him an eclectic : only he could not bathe at the Lido (let no literal-minded person assume that he did) without catching Tiepolo, or walk in the Luxembourg gardens without thinking of Rubens ; and for Fragonard, to think of Rubens was to knock off a picture in the manner of a Rubens sketch. For all that, his personality is not lost in his infatuations : a Fragonard is always a Fragonard, brilliant, lively, succulent, and sometimes bewitching. It would be impossible to fling paint on to canvas more seductively or faster. The Goncourts call him a realiser of dreams, which is pretty enough. He even went to the point of realising the dreams of others, for instance

of M. de Saint-Julien, financier and *receveur du clergé*, who dreamed that a bishop was swinging his—the financier's—mistress while he—the *receveur du clergé*—from his coign of advantage at the foot of Falconet's *Amour discret* enjoyed " les joyeux hasards de l'escarpolette." He liked the theme so well that he made two versions of it, and one you may contemplate any day you please at Hertford House. Every now and then Fragonard gave way to the circumambient pressure and stuffed a pinch of sentimentality or foolish anecdote into a picture, as you may also see at Hertford House ; and in old age —he lived on into the reign of David and Napoleon—he had to toe the line and speak of gods and heroes. But, all things considered, we must allow that he kept his art surprisingly pure, heeding not much the scribblers, save only his old friend Sedaine, who sagely counselled Gabriel de Saint-Aubin :

" Laisse tous ces héros d'Homère. . . .
Crayonne plutôt pour Cythère
   Quelque sujet tendre et galant,
Un rien, une esquisse legère
   Sur ce quarré de papier blanc."

" Tendre et galant " : Fragonard was gallant, but I doubt whether he can be called tender. He was too passionate, and he painted too quickly. Rather, after spending half an hour in his company, would I fit him with another motto—" le diable au corps."

Two painters in this period, and two of the best, are not of it : Duplessis (1725–1802) and Louis Moreau (1739–1805). One looks back, the other forward. Duplessis was the best French portrait-painter between Perronneau and David. He was a provincial. whose work smacks always a little of his origin. He was behind the times, and when he tried to come abreast made rather a good job of it, as in that " portrait d'expression " of Gluck. On the other hand, his portrait of Madame Lenoir, in the Louvre, is a sound, satisfying piece of painting which takes one back for a moment to the world of Philippe de Champaigne. The forward-looking Moreau—not that he dreamed of playing the pioneer—makes one think of Corot rather. He is perfectly innocent of the tricks of his age, and instead of painting classical landscape according to the cookery-book

positively painted what he saw in the suburbs of Paris. Here is someone as direct almost as Pissarro or Monet, someone interested in what he sees. That picture of his of St. Cloud, when one comes on it in the eighteenth century room at the Louvre, never fails to surprise by its unostentatious modernity.

But the representative figure of the age is Greuze (1725–1805) ; Greuze led by his animator and head-turner Diderot (1713–1784) and followed by Madame Vigée-Lebrun (1755–1842). Often have I tried to make myself and others believe that Greuze had painterlike qualities. Maybe he had ; after all Diderot had magnificent literary qualities. But the good qualities of Greuze disappear beneath such a mess of vulgar insincerity as seldom or never was smeared on canvas by one whom even for a moment serious judges took seriously. To think charitably of him one must think of certain portraits (*e.g.* the portrait of Wille in the Jacquemart-André collection) wherein a sensuous joy in paint keeps him fairly honest. This sensuality of Greuze—and in his way he was as sensual as Ingres himself—

has been the cause of much unnecessary objurgation on the part of healthy-minded critics, the case being that, as Diderot disapproved of open lust in pictures, the painter was obliged to dress his up as prurient sentimentality. Now of this prurience the critics disapprove. They cannot stomach those touching maidens who cassent la cruche and fondle pigeons and are in truth notable demi-vierges, cunningly contrived to bring tears to the eyes of the innocent and to les vieux messieurs quite other sensations. Certainly Greuze is a master exponent of what Mr. D. H. Lawrence calls the dirty little secret, and if that were all I should not be at the trouble of denouncing him. But Greuze and his inheritrix, Madame Vigée-Lebrun, have ejected across the ages a slime so copious and penetrating that a great deal of what is most repulsive in the popular pictures of the last hundred years can be traced to them. *Les enfants d'Edouard, A distinguished member of the Royal Humane Society, Bubbles, Vertige*, are to be laid at their door. They are the source of the infection. We catch of you, Greuze.

Take one too well known picture, *L'Accordée de Village* ; it will suffice. It might be the final tableau of a sentimental operetta, for everything about it is melodramatic, effective and false. Diderot had laid it down that a good picture was a picture that provoked good emotions—provoked, not expressed, mind you—and provoking emotion is the grand affair of Greuze. Unless he can make the spectator pipe his eye and feel the better for it he has failed. It is of you and me he is thinking always, and we get our money's worth. Diderot says that a picture should say something, and this picture says something with a vengeance. It says that, spite of all, virtue will be rewarded, and says it with unfaltering emphasis and obviousness. That is the moral, and the moral dictates the composition, the drawing and the colour, all of which are deplorable. The composition being designed to produce the maximum of melodramatic effect, every gesture is exaggerated ; also each figure is treated separately, for of such exemplary characters you would not have a single one stinted

of his or her share of limelight. That is why the accent is everywhere equal, as it should be when the comedians come forward to take their call : no object of edification remains in the shade. Unluckily this impartial apotheosis, this demand for indiscriminate admiration, necessitate the elimination of relation and restraint and make for unsubtle drawing. Have you heard our tenor trying to give every note the maximum of expression ? Have you had a taste of the tremolo ? Most detestable of all, the colour is hot, inharmonious and licked. Then why is this the most popular picture in the Louvre ? The critic Diderot, writing about this very picture, shall reply :

" C'est vraiment là mon homme, que Greuze. D'abord le genre me plaît : c'est la peinture morale. Quoi donc ! le pinceau n'a-t-il pas été assez et trop longtemps consacré à la débauche et au vice ? Ne devrons-nous pas être satisfaits de le voir concourir enfin avec la poésie dramatique à nous toucher, à nous instruire, à nous corriger et à nous inviter à la vertu ? Courage, mon ami Greuze, fais de la peinture morale et fais-en toujours comme cela."

He forgets to add that *l'amico* Greuze has

had the amiability so to render the accordée and her little sister as to make us feel what the idlers crowd round the steps of St. George's, Hanover Square, to feel. Be sure those compassionate spinsters who snivel over the youth and innocence of the bride are as well catered for as les vieux messieurs. Both get their thrill, though Diderot says nothing about it. However, bepraising another picture, *L'oiseau mort*, he rectifies this omission :

"Le sujet de ce petit poème est si fin que beaucoup de personnes ne l'ont pas entendu ; ils ont cru que cette jeune fille ne pleurait que son serin . . . Elle pleure autre chose, vous dis-je."

In a few years the uplift movement produced what uplift movements will, a welter of vulgarity. Into fashion comes "the picture of expression," which does not mean, as you might suppose, a picture that expresses something (had they meant that they might have dropped the qualification) but a picture that suggests, and by suggesting makes the public feel, the sort of feelings Rousseau recommended. Indeed, for "pic-

ture of expression " was substituted some-
times " picture of sentiment " ; amateurs
were known as " men (or women) of feel-
ing " ; Rousseau in *La nouvelle Héloïse*
announced that " exister c'est sentir " ;
and all the while the philosophers were
explaining that virtue is the sole source of
beauty—so Tolstoy was not original after
all. You can guess whither all this led :
it led from cruches cassées and tempting
laitières with their arms round donkeys'
necks to Madame Lebrun with hers round
her daughter, to that other gifted lady the
Labille-Guiard, to Vestier, Trinquesse, Wille.
The nasty trade, begun in genre, was soon
taken up by the portraitists. Portraits of
expression, the " en-allée " or " profil
perdu "—a line taken over from the English
and bungled—were all the go. Those
dreamy Richardsonian beauties divined
against elusive backgrounds that open up
vistas of romance and conceal a world of
feeble drawing are what fashionable people
liked in 1780 and what they will like again
and again. Meanwhile the more philo-
sophic but not less hazy portraits of men give

a fine idea of what meditation or creative ardour can make of an all too normal noddle. Bachelier brings sentiment and melodrama into history, Lagrenée brings them into allegory ; and landscapes that sympathise with some refined or exalted literary emotion, landscapes fit for Rousseau to be read in, abound. The mawkish trickle is driven a little way underground by David and the imperial pedants. But when, in the nineteenth century, the scum of Davidism has coalesced with the scum of romanticism, it will be from Greuze, with his sentimental anecdotes and buttery surface, and from Madame Lebrun, with that fatal gesture of maternal affection and hideous, livid colour, that popular picture-makers will draw inspiration. Greuze and Madame are the old master and mistress of Victorian commercial art.

The school of Greuze and Diderot, of anecdote and uplift, was the literary reaction from the regency. Beside it, but detached, went a genuine painters' reaction from the school of Watteau and the *fêtes-galantes*. This at first took the form of a

return to the tradition. The tradition of
the seventeenth century had throughout
the eighteenth been preserved in the
Academy, where the name of Poussin had
always been pronounced with veneration
and that of Rubens with mistrust. As
Watteau and his school became outmodish,
the Academy, and with the Academy the
tradition, came in for a little mild attention
from the more lively painters. Unfortun-
ately, this tradition which the Academy still
cherished had become what traditions left
in the hands of academies must become—
anæmic ; and when they tried resuscita-
tion the invalid was found to be past help.
All that the Academy could remember of
the grand siècle was its pomposity, its
declamation, its punctilio, and the acid
greens and blues, the masses of empty brown
shadow and inharmonious contrasts of that
depressing Bolognese colour-scheme. So we
need not regret the tradition. It was soon
put out of its pain by neo-Classicism, which
decreed that a picture should resemble so
far as possible a Roman bas-relief. The
current was setting in that direction years

before the Revolution, setting so strongly and so obviously that suddenly on this technical point up bobs philosopher Diderot to complain that Boucher's decorations are "impropres au bas-relief." Vien and Vincent put the axe to the academic tree ; David brought it down. In 1785 he exhibited *Les Horaces*. Whether some legitimate child of the tradition, begot on the female heir of Poussin by a virile descendant of Rubens and Watteau, could have been brought to birth at the century's end, and whether such issue could have withstood the Davidian onslaught had that onslaught been purely artistic, I do not know. I doubt it. Anyhow, the citizen David, member of the Convention, member of the Committee, and saluted master by Napoleon, was irresistible. By Act of Parliament he abolished the Academy and the tradition went with it. Then, for twenty-five years he reigned supreme, and when he fell he left behind him a clean slate. What will the new age write on it ? Not the name of Poussin and the tradition, nor large the name of any school—at any rate till we

come to Impressionism. But it will write the names of individual painters of such power and glory that for the like we must go to Florence in the fifteenth century. The Davidian saloon we must visit, but we will not linger ; for we are on the edge of the supreme epoch in the history of French painting, of one of the greatest in the history of art.

## *THE GREAT AGE*

How can one write a chapter on a subject about which only a year or two ago one wrote a book ? Another and much longer book about French painting in the nineteenth century I might write, and write with pleasure, since filling out with details a familiar shape is an easy and agreeable task ; but to boil down what I flatter myself is already a pretty strong broth would be for the cook a too melancholy business and for the customers would leave a sediment too unappetising. I propose therefore to take refuge in the uniform which I assumed at the beginning of this essay and play more modestly than ever the part of cicerone. There are great men to be pointed out ; there are classifications, rough but possibly helpful to those who care to see great men in relation to their age and to each other to be attempted : those two menial tasks performed, the guide may, I think, with a good conscience leave his patrons to enjoy them-

selves amongst the magnificent but singularly accessible masterpieces of the nineteenth century.

I call the French painting of the nineteenth century accessible, because to my generation and the generation that is coming into possession it is so. No man or woman of sensibility born since 1880 seems to find much difficulty in appreciating Ingres and Géricault, Chassériau and Corot, Courbet, Manet, Monet, Seurat and Cézanne. Far more than with the great Italians of the fifteenth and sixteenth centuries are we at home with these masters who, nevertheless, to their contemporaries seemed inaccessible almost. "Inaccessible," it is a mild epithet ; "repulsive" would be nearer the mark. Why, it was only because a wide diffusion of wealth enabled all sorts of people, amongst them cranks and highbrows, people of exceptional taste and intelligence that is to say, to purchase pictures, that many of these accessible masters were able, when young, to earn a living. So here at the outset we are confronted by the puzzling fact that the nineteenth century,

which is distinguished by an extraordinary efflorescence of individual genius, is distinguished also by a monstrous lapse of taste. How are we to account for it ? The job of guide will not, I perceive, be so soft a one as I had hoped.

The facts which supply a key, or at least help to explain the riddle, are, I think, the collapse of the tradition as a result of David and the political revolution, and the comparatively wide diffusion of wealth which resulted from the industrial and political revolutions combined. Only in an age without a live tradition could artists have been so conspicuously, so uncompromisingly, so aggressively personal ; and only in a century when even cranks and highbrows were in a position to buy could artists have sold pictures so little like what the public expected. For the public also was affected by the new conditions. On the one hand were the people of culture who, having now no live tradition by which to judge, judged by a dead ; these people expected pictures to be like Davids or Poussins or Raphaels : on the other were the nouveaux

riches, who had been floated into the position of purchasers by that same wave whereon the cranks and highbrows rose, and who expected pictures to be like photographs or Greuzes. Because the tradition had been destroyed, the original artists stood alone, their art was individualistic ; and because it was individualistic it was inaccessible both to those who had no taste at all and to those whose taste was conditioned by a tradition that had become a convention.

I want to elaborate this, though in doing so I fear I must serve up the word " tradition " till it provokes a slight sense of sickness, for it seems to explain a good deal of what once seemed odd in nineteenth century painting and still seems so in nineteenth century appreciation. Till the nineteenth century the patrons, though many of them no doubt were stupid and coarse-grained enough, all, or almost all, had been educated in a tradition of taste ; while the painters, though mostly capable of producing mere empty pastiche and often capable of producing nothing else, had been educated

in a tradition of painting. Thus it came about there was no painter so degraded but knew that art was something different from imitation, that for a portrait to be merely life-like was not enough : thus it came about there was no patron but knew or had to pretend he knew it too. Till the nineteenth century, painters and patrons alike had all been dipped in a tradition which gave to the work of the former some tincture of style, or at least of the appearance of style, and to the latter some idea of what was what.

One result of this was that the worst seventeenth and eighteenth century pictures are incomparably less bad than the worst nineteenth, another that even highly original genius expressed itself in a plastic language not altogether incomprehensible to the more intelligent part of the educated public. Now when it presents itself in forms more or less familiar, when it looks more or less like something we have all been brought up to admire, original genius is acceptable ; only when, having lost the old stage properties, it comes naked before the public

is it recognised for what it is—something profoundly disquieting. Like all great artists, the masters of the nineteenth century were original, personal at all events; but unlike the artists of happier ages, who found ready to hand a live traditional style with which originality could come to terms, they were forced by circumstances not only to reveal but occasionally maybe a little to parade theirs. For this slight and occasional emphasis on their individuality they can hardly be blamed: it was the inevitable reaction to ignorant hostility. Assuredly it was not the emphasis that enraged the public. Renoir had not the faintest desire to call attention to his originality; it was the disconcerted public that did the calling.

A further consequence of the revolution has to be noted. Alongside the unadaptable and strangely insensitive connoisseurs we have seen appear a new breed of patrons— the nouveaux riches, the Victorians par excellence. To cater for these arose a new race of painters, the big commercial men, British royal academicians and French sociétaires and great international undertakers,

Landseer, Winterhalter, Delaroche. To an age in which the law of supply and demand was expected to work, what could be more incomprehensible than a work of art, something made not to please the purchaser but to express the maker's feelings? Is it surprising that by such a public all the great artists should have been greeted, on their appearance, with insults and abuse, except Corot who got nothing but contempt? It is not. What still surprises and shocks a little is that the great painters of the nineteenth century should have met with such a reception, not from the common herd only but from cultured respectability and official connoisseurship. I have offered my explanation of this lamentable fact, and whether it be accepted or not the fact remains. It cannot be denied that the officials, the directors of galleries, the critics of the great newspapers, the high priests in fact of the temple of art, joined their pontifical animadversions, couched as a rule in language of startling violence, to the bellowing of the mob. Whether this is to be attributed, as I attribute it, to a willingness

to make use of any stick, popular taste or Billingsgate, for so good a purpose as cudgelling live artists who could not conform to a dead tradition, or whether it was rather a reverent submission to the *vox dei*, so audible in the nineteenth century, is a matter of no great moment. The important and painful thing to remember is that, for one reason or another, those people who appeared to care passionately for the genuine art of past ages combined with the wholly tasteless and ignorant to denigrate the genuine art of their own.

The sort of contemporary work in which they delighted is revealed by their official purchases, of which most have by now been safely stowed away in attics and cellars and provincial museums. I do not suppose many of these scandalous witnesses will be allowed to cross over to Burlington House— where however they should feel very much at home—officials being of an exemplary loyalty in the matter of covering up their predecessors' messes. Indeed they seldom lack hardihood in denying their own ; and it is the commonest thing to meet some aged

director who will tell you how much he has always admired Renoir or some middle-aged critic professing a life-long devotion to Matisse, painters for whom, as a matter of fact, in earlier days they could find no names too bad. Wherefore, perhaps, it is to be hoped that just two or three samples of official discrimination will be on view— a Delaroche, say, a Meissonier and a Besnard—to serve as warnings. For the game still goes on. If to-morrow a new, unorthodox genius were to begin doing what Giotto and Raphael and Rubens and Renoir did, but doing it in an unexpected manner, in the manner neither of Cézanne nor of Matisse nor of Picasso, be sure the latest in authority would be at him almost to a man, and would be screaming " idiots," " perverts," " bolsheviks," at the handful of cranks and highbrows who recognised a new artist in unfamiliar clothes. Yes, and a dozen years later these same pundits, obliged at last to bow to superior judgment, would be talking as though they had been always of that mind and still calling the cranks and highbrows perverts and bol-

sheviks. Anyhow, in this chapter I intend to say not a word about the painters whom officials approved, but to devote my space to those whom they hindered at the time they needed help and for whom they now profess a tardy admiration.

The age of David—the Republic and Empire—was poor in art of every sort, and in the three major arts beggarly. Nor can this surprise us when we consider how many of the most gifted and sensitive French men and women had been either executed or exiled by a central government which gave the finishing touch to its work by taking art and letters under protection and directing them towards patriotic ends. There are exceptions of course : did I not admit that my classifications would be rough ? But I suppose Chateaubriand, Benjamin Constant and Madame de Staël will hardly be claimed as Imperial writers, while Ingres, who accepted the dictatorship quietly enough, lived till 1867, so that he belongs only partially to the period. Roughly, it is true to say that while Revolutionary and

Imperial writers were trying to hash up for present consumption the remnants of the heroic seventeenth century, the painters were seeking a style worthy Alexanders and Catos in a misconception of Graeco-Roman sculpture.

> " Le Dieu dont les pavots ont la vertu propice
> De reposer nos yeux du spectacle de vice,"

wrote the citizen Luce de Lancival. The couplet gives a fair idea of civic poetry.

> " Hercule tuant Rhésus, et faisant manger les
> cadavres de ses ennemis par ses chevaux "

is not, as you might imagine, a specimen of civic prose but just the title of a picture by le baron Gros.

Artists are rarely the better for dictation of any sort, and the ideas which the dictator David promulgated were peculiarly unhelpful to painters. Subject he held to be of the highest importance, and subjects, he held, should when possible be drawn from classical history or mythology. But whencesoever drawn they should be treated as though they were bits of Graeco-Roman

sculpture, and the naked human form, the proper study of artists, should be bounded by a sharp insensitive line so as to look as far as possible as though it had been cut out of some hard material. Though almost inevitable in painting, the use of colour is regrettable ; keep it as flat, metallic and inconspicuous as may be. Also, since classical sculpture is at its noblest in single figures, see to it, if compose you must, that the figures in your composition be severely disconnected. Last, but not least, never forget that the finished work is to be of a kind to inculcate such moral ideas as become the citizens of a free and enlightened republic. As was to be expected, the outcome of these precepts was a cold, declamatory abstract art, in which abstraction served, not to facilitate design, but to give emphasis to ideas. Certainly, with the full blossoming of the Empire, more attention had to be paid to detail and colour. How else could justice be done to coronation robes and generals' uniforms ? But indeed to follow the development of David and Davidism you must follow the development

of contemporary politics, for about Davidism there was something political always.

At this new game—the use of colour and massing of details—le baron Gros (1771–1835) outdid the master, producing a number of attractive pieces, and perhaps inspiring to some extent Géricault, the pioneer of the colour revolution. There will be more to be said about Géricault before long, at present it is of David I would be talking. Historically he is immensely important because he cleaned the slate. As a creative artist he is far from negligible, for when he could forget his doctrine that a picture should resemble a bas-relief he painted finely. He is seen to greatest advantage in his portraits, where he is thoroughly in the French tradition—I do not mean the tradition of Poussin but that fundamental tradition, the tradition of Fouquet and the Clouets : he is observant and direct and relies on his manipulation of paint for producing the naturalistic effect he aims at. Also, without being either tiresomely (like La Tour) or subtly (like Philippe de Champaigne) psycho-

PLATE XXIII

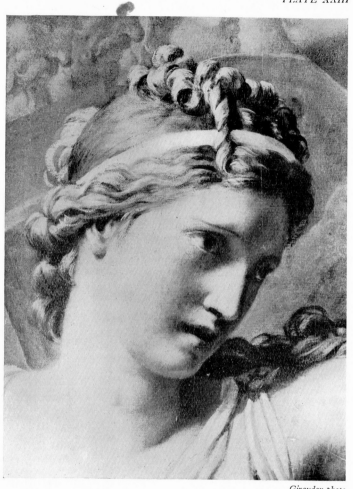

*Giraudon photo.*

David                                    Les Sabines (détail)

logical, he gives the essentials of a crude character with commendable vigour. Of his school Ingres (1780–1867), if scholar you insist on reckoning him, is of course by far the greatest, far greater than the master. But truly Ingres is of no school ; he is of the masters. He is one of the great painters of all time ; besides, most of his work was done after 1815, the year in which the regicide David was banished to Brussels. Ingres gave nineteenth century criticism a chance of showing its brand-new teeth. He was the first of that long line of great artists whom the age delighted to dishonour. He was welcomed by the conservatives with what was to become their customary affability and discernment : he was called " subversive," " a botcher," " a vulgarian," and of course he could not draw. The portrait of Mlle. Rivière was dubbed a " chinoiserie," and the Pourtalès *Odalisque* a bad imitation of an Indian miniature. From this bog of nonsense emerges a wisp of instruction. If by correct drawing is meant an apish imitation of the model, Ingres, like every other great artist, was

incorrect. He distorts fantastically : he distorts in order to express. The line of Ingres is as expressive as the line of Raphael. What more can be said ? That his colour is often repulsive (perhaps after all he does owe something to the Davidian doctrine) ; that his composition is often clumsy ? Yes, but keep your eye on the drawing, follow those thrilling contours which, without shading or niggling but with one strenuous bounding line, render the whole content of a form, and see whether you can resist the conviction that here is a very great artist.

Le baron Gros (1771–1835), Gérard (1770–1737) another baron, Guérin (1774–1833) and Girodet (1767–1824) may be taken to represent pretty fairly the school of David. Guérin was a born truant ; he is of the school none the less. None is without talent, all have been so well drilled as to appear almost without personality. Their art is impersonal, abstract and declamatory —just what it should be, in fact. On the other hand Prud'hon (1758–1823), though he came to call over—he knew better than stay away—was always stealing out of

*PLATE XXIV*

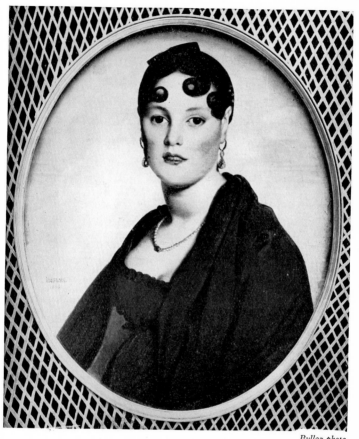

Ingres

La Belle Zélie

bounds. His classicism is of the eighteenth century rather than the Empire ; his gods and goddesses are amiable rather than sebast. Also he was a painter, and a sentimental poet to boot, who discovered a moonlight effect which is not without its vicious charm ; while to the anatomical design and cutting contrasts of David he preferred construction in soft and usually monochromous touches, reminiscent rather of Correggio. Assuredly he is not comparable with the mighty Ingres or the eminent David, but I do think him a cut above the four famous G's.

While these were producing heroically, if submissively, in that fierce light which beat down on the Consulate and Empire, in a semi-obscurity illuminated by glances of envious contempt flourished the genre-painters : they will continue to flourish. That comfortable middle-class which began to become more comfortable towards the middle of the eighteenth century, and became more comfortable still at the beginning of the nineteenth, liked its comfortable little pictures to enliven its comfortable little parlours. Of parlour-piece makers there is no end. The

best remembered are Boilly (1761–1845), Drolling (1752–1817) and Dumarne, another of those Flemings (1744–1829). Their pictures are often pretty and amusing, and those of Boilly still command considerable prices. They are of no consequence.

Of no consequence either is the romantic movement—I mean of course the movement in painting—in so far as it was romantic. It differentiated itself from its predecessor by drawing the subjects of bad pictures from medieval history, the poems of Lord Byron, and the novels of Sir Walter Scott, instead of drawing them from the classical dictionary and Plutarch. The literary movement, to which pictorial romanticism attached itself and from which it took its name, is quite another matter. The young French writers, as weary of militarism as sceptical about the rights of man, certainly did find food of the most nourishing quality in English literature and German philosophy. On these they throve. But so far as painting goes, all that is important in romanticism is that it stands for the revolt of the individual against authority. As such, as a manifestation of

individualism, you may if you please make of
it a frontispiece to the most glorious period
in the history of French art. In the history
of painting proper what was important was
the colourist movement. About the year
1812 this movement, revolution it might
be called, unnoticed save by the sharp,
suspicious eyes of David, was set going by
Géricault. If you choose to lump together
—and it is what was done at the time—this
pictorial colourist movement and the literary
romantic, you can make of the product some-
thing that contrasts magnificently with the
old neo-Classical régime. You can set char-
acter against ideal beauty, sentiment against
reason, colour against line, the Middle
Ages against antiquity, wild nature against
Le Nôtre, and Rubens against Raphael. It
is not for me to deny that such contrasts may
be helpful to historians or journalists in
search of principles of classification. But the
mere lover of painting will notice chiefly
that Géricault's frank delight in sumptuous
colour, his intricate but logical composition
in masses, his passion for paint, and the
freedom and beauty of his brush-work, are

things new to this new post-revolutionary
world, things which inevitably make one
think of Rubens first, and then of the
English.

For the influence of English painting on
the new generation in France, though far
from being so great as the influence of
English literature, was considerable. In
1815 the two civilisations had been separated
for the best part of a quarter of a century ;
and while in England the eighteenth had
been developing normally into the nine-
teenth, in France the tradition had been
broken brutally and a lump of dead foreign
matter driven into the soft growing flesh.
Young French painters of the restoration
travelled in search of their past, and in
England they found it. Géricault spent three
years of his short life in London, whence
he wrote in 1820, " ici seulement on connaît
où l'on goûte le couleur et l'effet " ; while in
1824 Delacroix was bowled over by Con-
stable so effectively that he is said to have
withdrawn his *Massacre de Scio* from the salon
in order to repaint it on English principles.
That thirty-four years later he was still

mindful of the shock is proved by this extract from a letter to Théodore Silvestre : " Constable, homme admirable, est un des gloires anglaises. Je vous en ai déjà parlé, et de l'impression qu'il m'avait produite au moment où je peignais *Le Massacre de Scio*." Now Géricault (1791–1824) and Delacroix (1798–1863) are the twin pillars of the colourist revolution.

In the spring of 1930 the exhibition at the Louvre gave me an opportunity of taking the measure of Delacroix—in so far, that is, as I am capable of taking the measure of a great artist ; and a few months later I made a journey to Rouen expressly to renew acquaintance with Géricault. It is not inconsiderately therefore, however mistakenly, that I now declare my preference for the latter. The high esteem—one might say reverence—in which Delacroix is, and for near a hundred years has been, held by French criticism will not surprise anyone who remembers that he was one of the most influential figures in his century and one of the most dignified, that round him rallied spontaneously all that brilliant and generous

youth which was in revolt against the school and the code, that he was acclaimed—against his will—leader of the revolutionary movement, that he painted many large and admirable pictures, and that these possess a literary quality very welcome to, because appreciable by, the sort of people who create reputations. Delacroix is at once a real painter and a writer's painter ; his fame needs no further explanation : only the earliness of his rise to celebrity and, what is stranger still, official recognition need that. Certainly the purchase of the *Massacre de Scio* does need accounting for, seeing that purchase by the State of a Delacroix in 1824 was pretty much what purchase by the State of a Matisse would have been in 1910. If, however, we accept the by no means unreasonable hypothesis that Delacroix was the illegitimate son of Talleyrand, the mystery ceases to be mysterious.

Delacroix, unlike a good many good painters, had a mind, the sort of mind, I mean, that no critic in his senses can fail to notice ; it was a mind full of ideas and emotions rising out of ideas. These he conveyed

PLATE XXV

Géricault                                    Etude de Cheval

to the world, imperfectly, by means of his pictures. He gets at us by provoking, or trying to provoke, in our minds ideas and emotions similar to his own. He suggests, he recalls, but very rarely does he create. He never, or hardly ever, succeeds, it seems to me, in creating forms which are in themselves, without reference to what they represent or what they suggest, convincingly and surprisingly significant. Often as I have enjoyed a picture by Delacroix I have never been carried away by one. The enjoyment is a work of collaboration between the artist and spectator, not a windfall from Heaven. Now Géricault, a less remarkable man, strikes me as a more impressive painter because he can make additions to the world of pure form and colour. To appreciate his completely successful pictures—they are few—we feel no urgent call to correlate his forms with facts or ideas in our experience. He can enrich us gratis. Sometimes, by no means always —there was something tentative about his art to the end—he will create things which add a new, unbargained-for experience to our lives, an aesthetic emotion to the engendering

of which we have contributed nothing : those are the things that carry one away.

The salon of 1827 was one of the artistic events of the restoration : it contained the *Homer* of Ingres—one of the master's less satisfactory performances, wretched in colour and mechanical in design, but acclaimed by classics and romantics alike a triumph ; it contained the *Sardanapalus* of Delacroix—an alluring though muddled composition, full of fine Rubensesque passages, and of a rousing literary import ; it contained *La naissance de Henri IV* by the feeble Devéria (1805–1865), greeted by the more ardent and less judicious romantics as the greatest work of all, if not of all time ; and there was a picture by an unknown painter called Corot which, to the best of my knowledge, attracted no attention whatever. Jean - Baptiste - Camille Corot (1796–1875) is, as everyone now knows, one of the great French painters, but it is not easy to say in what his greatness consists. He was a man who combined a divine painting-gift —I use that dangerous epithet deliberately —with a direct and impassioned vision. He was far more of a poet than Delacroix, but

PLATE XXVI

*Giraudon photo.*

Vue de Paris

Corot

to him poetry came wholly through the eyes
and not at all through what he had read.
Indeed he read nothing and thought not
much more. He saw and felt. He is a
painter's painter. A chapter ago Claude, to
whom he owed a great deal, made us think
of Corot ; now it is Corot's turn to make us
think of Claude. I do not know whether to
admire most the Italian landscapes of his
first Roman period, the French landscapes
he painted just after his second visit to Italy,
or the figures he was painting all his life. I
incline to believe that his figures are his
masterpieces ; also he has left an illuminating
note on his state of mind when painting
them : " Je peins une poitrine de femme
tout comme je peindrais une boîte au lait."
At his best, like Chardin, he simply con-
templated the object with acute but loving
eyes and trusted to his genius to render what
he felt. Corot seems to have been without the
gift of self-criticism ; to put it bluntly, he was
stupid. He got it into his head that he
ought to become poetical, as if he had not
been that from birth ; and in this notion
rich amateurs and Daubigny of Barbizon

encouraged him. As a result he contrived to paint for M. Chauchard, founder and director of Les Grands Magasins du Louvre, some thirty pictures, bequeathed to the museum of that name, not one of which rises above the second rate, and few as high. Throughout the later part of his life he continued to produce these futile and fluffy idylls simultaneously with masterpieces of sincere vision and unfaltering expression. At one moment he would be painting figures and landscapes as though they were *boîtes au lait*, at the next peopling the faerie and feathery woods of Ville-d'Avray with winsome and semi-diaphanous nymphs. These last were for M. Chauchard and his friends ; such noble patrons desired and deserved a touch of Theocritus and Virgil (of whom, by the bye, he knew nothing), while the *boîtes au lait* were for his own satisfaction and our delight. When Corot is at his best—and they are sure to send some of his best to London—when Corot, that is to say, is himself—he is, within his limits, perfect ; when he is at his worst, *guarda e passa*. As for this analogy with poetry of which so much

has been said that I suppose one has to say something more : his vaporous idylls are at best bad Tennyson ; it is in his *boîtes au lait*, especially in the landscapes of his first Roman period, that he is in a sense Virgilian. His figures are beautiful always ; whether or no they are poetical is a question I have never found it necessary to consider.

Though the Barbizon school is an historical landmark, and though in its day it made a stir, it produced but two painters who have so much as a doubtful claim on the attention of a tourist racing through the nineteenth century. Neither of them is first-rate. Rousseau (1812–1867) was a conscientious artisan in whom unluckily the root of the matter was not ; Millet (1814–1875), a man of far greater talent, was afflicted with that sad disease of self-righteous sentimentality which renders the sufferer, no matter how gifted, incapable of producing a satisfactory work of art. Corot has nothing to do with Barbizon ; indeed, if find him ancestors you must (other than Claude) you had better seek them amongst those Davidian landscape-painters, " les paysagistes d'histoire," Bidault,

Bertin, Michallon, against whom Barbizon was pleased to consider itself in revolt. The importance of the Barbizon school— a convenient label for a tribe of painters scattered between 1840 and 1870 all over France and Belgium and by no means confined, as the name might suggest, to the forest of Fontainebleau—is that it forms a bridge between the Dutch land-scape-painters of the seventeenth century, with their English descendants of the eighteenth and early nineteenth, and the Impressionists. Historically, therefore, it is entitled to some consideration. It polished and enriched the vocabulary ; it made of Constable's splendid but idiosyncratic and untidy vernacular a teachable language of widest application, in which competent students of any nationality might learn, as only too many have learnt, to state what they had been taught to observe. This was of importance because the new instrument for recording observations fell into the hands of the Impressionists, who were beholden to it as a poet of genius might be beholden to some unusually sensible grammar unearthed

from a dusty corner of his schoolmaster's library. In itself Barbizon is almost negligible, being one of those by no means uncommon manifestations, a movement full of enthusiasm, honesty, industry and good will, which, lacking genius, comes to nothing. The pre-Raphaelites and the Parnassiens afford obvious parallels.

Perhaps we ought to take a look at the indefatigable Rousseau, and at Millet the greatly gifted prig. At the latter one is obliged to look ; there is no escaping a man so conscious of his honourable independence and mission in life. Of these he is as well aware as any English hedgerow artist or as one of his own peasants. Again and again an excellent design is sacrificed to the irrelevant self-assertion of some stoic swineherd or the claims of the ideal. Yet with all his nasty sentiment, his muddled colour (Millet never, or rarely, discovered harmonies adequate to his conceptions), and his stupidly deteriorated design, he is a man to be reckoned with. In his best drawings at any rate, when he is too much excited by the act of creation, of inventing an equivalent for

what he saw and felt, to be scrupulous about details, we find him eliminating, deforming and synthetising with the best. Forgetful then of social injustice and the curse on Adam, the importance of minute description and fidelity to facts, he can for a moment be an artist simply. If you want to think as kindly as possible of Millet keep your eye on his drawings. As for Théodore Rousseau, he was one of those conscientious and acute persons, never uncommon, and in the nineteenth century both abundant and prominent, who seem to have been born quite without temperament. Starting from Ruysdael, he noticed about nature a thousand facts which the Dutch master had either not noticed or not cared to mention ; and he contrived or perfected means for stating every one of them. What he could not do was to give them cohesion, for cohesion is obtained only under pressure of creation. He was an indefatigable observer, incapable of marking for his own what he observed, who accumulated facts which he could neither pen nor brand. His pictures are uninspired. The longer he lived the less he seemed able

to make anything better than accurately ob-
served transcriptions, surprising at the time,
original if you like, precisely by reason of this
unfamiliar accuracy. The faithful servant
of nature, he followed her, as Fromentin
says, " from the plain to the mountain."
But fidelity, like other virtues, is not enough.
Without ever sinking to the level of
Daubigny, who seems to have produced pic-
tures as Mr. Ford does cars, he repeats himself
drearily. It is not, assuredly, that all he did
bears the impress of a too insistent character,
nor yet that all his pictures are the products
of one recipe—the cause of Daubigny's
monotony—but that all are the faithful
records of one pair of honest eyes with
nothing various behind them, nothing but
competence and good will.[1]

To jump straight from these middling
provincials to Courbet, the pivotal figure of
the age, seems absurd somehow. I mean it
might give you the sort of shock I once got
when an eminent critic observed that there
was no reason for despairing of modern art

[1] These remarks on the Barbizon school are drawn from
*Landmarks in Nineteenth Century Painting*, where the historical
importance of the movement is more thoroughly discussed.

when such men as Degas, Renoir and Brangwyn were alive. To bridge the gulf let me say a word about three artists who cannot conveniently be brought into the rough classifications with which I am helping myself across this mountainous country : a great draughtsman, a sculptor of note who also painted pictures, and a very great artist —in my opinion the greatest decorator of the century. The draughtsman Daumier (1808–1879) is indisputably one of the big men. Draughtsman, I say, because about his paintings I am heretical. Daumier never had a master proper : here and there he picked up scraps of technical instruction, but to see and to express with amazing force and vivacity all that came into his head through his eyes he learnt in the streets of Paris, whither he was brought at the age of seven from Marseilles. Later he spent long hours in the Louvre before the masters of the high Renaissance and especially before Rembrandt ; and these masters imposed on his turn for vivid annotation a style—a slightly declamatory style. At heart he was half a sculptor, and in early days had been in the

habit of realising his visions in the three-dimensional medium, making little clay or wax images of his victims before dispatching them with his murderous lithographer's pen. Also the besetting sin of his drawing and painting is a painter-sculptor's vice : he relies too much, at least so it seems to me, on the rhetorical effect of cast shadows and sharply accused planes ; he does not make sure enough that those dark and impressive masses continue a contour or correspond with an observed fact. The laws of gravity protect the sculptor from the dangers to which the sculpturesque painter is exposed : an empty shadow will not support a marble head. Into the bargain Daumier was a radical politician, and, like most radical politicians, a reactionary moralist ; so we need not be surprised if his art is sometimes over-massive and declamatory, not to say strong. Let us not forget, however, that chronic poverty, the daily necessity of boiling the pot, prevented him giving the best that he could have given in paint. Because he sometimes fled for peace to the forest of Fontainebleau, because he was friends with

some of the sincere and likeable men who habitually worked there, occasionally he is reckoned a member of the school. For this there is no good reason ; nor is there better for so reckoning Barye. The sculptor Barye (1796–1879) is well known by, and more than sufficiently admired for, his figures of animals. No one in his senses would deny that he observed them with prodigious accuracy—more accurately perhaps than animals had ever been observed in Europe before—or that he rendered his observations with brilliantly adroit realism. When he could bear the smell of the Jardin des Plantes no longer he too hurried off to the forest with a sketch or two of lions and tigers in his pocket, and of these subjects made clever display on some sandy patch beneath the grey skies of northern France. Thus he came to be considered a member of the Barbizon school.

We are in mid-century now. The weary game of Classicism versus Romanticism is still waged on paper, in the press Ingres is still pitted against Delacroix ; but the rank and file, the standing mob of painters, has by now coalesced to man the factory. Whether we

*PLATE XXVII*

Chassériau                    Venus Marine

consider the " Romantic " Delaroche or the " Classical " Ary Scheffer, we perceive that the fundamental purpose is the same—to give the paying public what it likes : the same likewise the quality of the article given. One great painter, however, did attempt a genuine, an artistic, syncretism ; Chassériau (1819–1856), the favourite pupil of Ingres, endeavoured to saturate the master's perfect forms with the rich colour of Delacroix. The fate of Chassériau's decorations is one of the tragedies of painting : here is the heaven-sent decorator who was positively given his chance—for all that he died at the age of thirty-seven his output of wall-painting was abundant—and of whose work what has escaped the furious vandalism of communists has been allowed to perish by the lethargic vandalism of Church and State. In the art of Chassériau there is a clash of styles and temperaments : " C'est un Indien," said Gautier, " qui a fait ses études en Grèce " ; also it is a pupil of Ingres who has come under the spell of Delacroix. From this clash springs a strange exotic beauty. Chassériau devoted his short and passionate

life to an attempt to combine the narrow intensity of Ingres with the generous profusion of Delacroix and out of the two styles to forge an instrument capable of expressing his own contradictory temperament. For the conflict of styles corresponds with a conflict more profound ; his was the temperament of a non-European in love with Hellas—but pray do not think of Luria, for there was nothing priggish about Chassériau. This temperament found expression in suave forms at once expressive and comprehensible, at once ardent and indolent, at once decorative and of an adorable purity. I can but repeat what I have said elsewhere : the conception Chassériau had to externalise was a sense of what life might be if only time would stand still and allow us to walk round our fiercest desires, contemplating and enjoying them languidly ; the miracle is that he not only expressed himself but expressed himself classically. Chassériau, by the way, is answerable for almost all that is alive in the huge output of Puvis de Chavannes (1824–1898).

Gustave Courbet (1819–1877), who called

himself a realist and was called the apostle of social democracy, was a magnificent traditional painter, the great eclectic of the nineteenth century. When this vigorous and pushing young peasant from the Franche-Comté arrived in Paris—it was in 1840—he began talking big about the deplorable state of the world in general and the arts in particular, and let anyone who cared to listen know what he proposed to do about it. Like a good many more French peasants then and now he was sturdily radical and vehemently anti-clerical ; wherefore, when he had become famous or at any rate notorious—and he was that as early as 1849—the social-philosopher Proudhon and his friends began to take notice. Courbet made no objection : he never did object to anyone taking notice of him for better or for worse. He was amongst the earliest and most successful exponents of the now familiar craft of literary and artistic self-advertisement. So when the advanced thinkers discovered that he was the first painter of the new dispensation, of the social-democratic millennium that is to

say, and went on to explain that on this account he was not only the best living painter but the best painter that ever lived, Courbet was at no pains to contradict. " Le Réalisme est une aspiration démocratique," announced Champfleury ; " Ne voyezvous pas s'ouvrir de nouveaux horizons," added Thoré ; on which Napoleon III slapped a *Baigneuse* with his riding-whip. All this was quite satisfactory ; but when philosopher Proudhon went further and in his *Principe de l'Art* enunciated the axiom that —" Dix mille citoyens qui ont appris le dessin forment une puissance de collectivité artistique, une force d'idées, une energie d'idéal bien supérieure à celle d'un individu, et qui, trouvant un jour son expression, dépassera le chef-d'œuvre "—it is certain that Courbet would have protested had he heard what was said. Luckily Courbet was not in the habit of paying much attention to the words of wisdom that fell from the lips of the philosophers unless they bore directly on himself or his works. As a matter of fact he did paint a few definitely tendentious pictures—one, I remember, called *The*

*Return from the Diocesan Conference*, or something of the sort, which was meant to be an attack on the clergy : they all happen to be very bad, though not worse than other and unpolitical pieces. The fact is, whenever Courbet lost interest in his subject or a detail of his subject, no matter what that subject might be, whenever he lost hold of his inspiring vision, he painted pretty much as popular academicians paint—here presented, that is to say, what the grocer thinks he sees. Living as he did amongst revolutionaries, Courbet found himself in 1871 almost automatically a member of the Commune, in which odd situation he appears to have behaved with unlikely and unliked common sense. By the third Republic he was persecuted and his pictures were excluded from public exhibitions. It is as satisfactory to know that almost all the good painters in France, as well as many of the bad, protested against this outrage, as to learn that the chief of the anti-Courbet gang was Meissonier. So much for the politician.

The painter Courbet, newly arrived in Paris, did not spend all his time spouting in

the cafés.   He went off to the Louvre some-
times and there studied to good purpose the
works of Hals, Velasquez, Ribera, Rem-
brandt, and the great Venetians.   Not only
did he study ;   he copied.   From these
masters he learnt to render his own tre-
mendous sense of matter.   His passionate
feeling for matter, its glory, and its power of
provoking emotions which have the force of
sensations, was what stirred him to paint ;
and only when he was so stirred did his fine
acquired technique come fully into action.
The moment this sense of the fact deserted
him he painted as poor Poll talks.   It was not,
however, his masterly manipulation of sump-
tuous oil-paint, nor yet the cold and lifeless
representation into which he fell when
enthusiasm waned, that earned him a bad
name with officials and the knowing public,
but that he was what they called a realist,
by which they seem to have meant that he
painted monumental canvases, in the grand
manner too, of the subjects he knew best.
Of himself to begin with—Courbet liked his
own looks, not unreasonably—of the rocks
and glens amongst which he had been reared,

of all the gear and trappings of a small-
holder's existence, of the ample forms of
women in the class from which he sprang,
of all these Courbet made pictures which
claimed unblushing equality with the
" great " art in the museums. This it was
that enraged the connoisseurs and the general
public—the vulgarity of his subjects and the
exorbitance of his claims. And it was this
that thrilled the young and enterprising.
This magnificent assertion that an artist
must paint whatever excites him, that
nothing is more exciting than the common
sights of daily life, and that out of these, if
he be seer and craftsman enough, he can
make pictures to take their places beside the
masterpieces of the world, came to his young
contemporaries as a gospel of release, a
creed that justified their inmost convictions :
even to-day the virtue of the affirmation
is not spent. And can anyone who has
contemplated in the Petit Palais *Les
demoiselles de la Seine*, those two mid-century
fun-girls taking an afternoon off, who has
admired the magisterial drawing and re-
sponded to those harmonies as amorous and

imperial as an autumn garden, can anyone deny that this picture does take its place with the masterpieces from which it derives ?

Manet (1832–1883) is the direct descendant of Courbet : not till long after he had painted his most important pictures *Le Déjeuner sur l'herbe* and *Olympia* did he begin to experiment in pleinairisme. It was from Courbet he inherited his style, his belief in painting familiar scenes in the grand manner, and that immense load of senseless hatred which had accrued to the master. The pleinairiste doctrine, one must remember, was not elaborated till 1871 at earliest ; throughout the " sixties " Renoir, Monet and Cézanne were all more or less under the influence of Courbet, while that painter of promise Bazille (who was killed in action) never came under any other. The enormous prestige enjoyed by Manet amongst these younger men, who were to become the great Impressionists, may be attributed partly to the fact that he was the heir of Courbet, partly to his distinguished and admirable character, for as an artist he is singularly uneven and unsure—by no means the born

*PLATE XXVIII*

Courbet

Les Demoiselles de la Seine

leader. His technical innovations, compared with those of the pleinairistes themselves, are insignificant. He was abused and applauded for juxtaposing bright colours in broad patches instead of leading up to them through a series of semi-tones, also for banishing "shade," that is for making shadows out of colours ; but seeing that such accusations can be brought home to the Spanish masters and to Hals, and that the Italian primitives stand convicted of habitual juxtaposing, it is hard to believe that the painters and professional critics were seriously disconcerted by such well precedented practices. But Manet was a realist in the manner of Courbet—and worse : it did not take a critic to see that. He chose trivial scenes from contemporary life—a model who has just been bathing sitting naked between whiskered artists or a demi-mondaine accepting nonchalantly from her black maid, as she sprawls on her *lit de repos*, a bouquet sent by some kind keeper—and treated them neither as scenes of shocking depravity nor yet as peeps at appetising vice, but as subjects. Worse still, he flattened them out. That was

too much. To take contemporary life, which is, of course, "inartistic" but "real," and make it look as unreal as a work of art was more than bourgeois flesh and blood could bear. It was enough to make Manet a celebrity ("plus connu que Garibaldi," said Degas) to be loved past reason and past reason scorned. And one ought not to forget, though in the irrelevant hubbub one does easily, that all the while he was an uncommonly good painter, in itself a reason for unpopularity with the herd. His work I have admitted was strangely uneven. He has left us lovely things ; yet through almost the whole of his output runs a trickle, I will not say of vulgarity, but of commonness. It is this that now dismays and puzzles one.

Before beginning to admire the Impressionists let us take a look at two artists who also may in some sort be reckoned precursors, Constantin Guys and Eugène Lami. The reason why one cannot put Lami (1800–1890) aside, with those genre-painters who from Greuze onwards pullulated in France and indeed throughout Europe, is that he is

so much better. Indeed he is of another class ; his work, so far as I know it, being neither cheap, sentimental, improving nor anecdotic, though slight. Like Guys, he found in the spectacle of contemporary life, in its pomps and pageants, in the passing show, motives for lively and brilliant painting ; need I say that he rendered them with less force, less genius, than he whom Baudelaire has canonised as *Monsieur G. peintre de la vie moderne* ? But Lami's colour is often enchantingly subtle, his touch bold, rapid and, what is much rarer, decisive ; his vision witty. I do not know that the Impressionists owed anything to him directly, but a picture by Lami hung amongst theirs would not look out of place.

Constantin Guys (1802–1892) is another matter. He is a man of genius and an inventor. Like Lami he is a genuine artist moved to self-expression by the passing show ; but there the likeness ends. Guys is like no one who came before him ; he is not a caricaturist, for he never condemns, satirises or denounces ; he is not a sentimental anecdotist, for he neither pities,

prattles nor approves. No Daumier, no Greuze, he is not a Dutchman either ; he is not humorous, he neither grins nor smacks his thigh. He is not indignant, he is not edifying, he is not even sly. By the spectacle of life he is neither saddened, elated, irritated nor amused : he is fascinated. Precisely to render his sense of this fascinating spectacle is his passion. But he must be quick. The passing show passes. And so he invented a technique. From the street he hurried back to his attic—for he did live in an attic, though I know it was dreadfully artistic of him—to realise his vision while it was yet fever-hot ; and to realise it he invented that nervous, broken, telling shorthand which was to become an indispensable instrument of graphic impressionism. With what I call pictural impressionism and the doctrine of the scientific palette, with Monet, Pissarro and Sisley, he has nothing whatever to do—though when he charges his brush with colour he uses it as deliciously and rapidly as when he charges it with ink or sepia ; but of impressionist illustration, of Degas, Lautrec, Forain, he is one of the

masters. Without Constantin Guys that essentially modern reaction to contemporary life, that passionate but impartial pre-occupation with the actual and evanescent, could hardly have been rendered in line. Visually he is the benefactor of us all, for he has added a scrap of delectable territory to the province of the eyes. Not only painters, but novelists and intelligent lookers-on, Jean Cocteau and Aldous Huxley, Paul Morand and Virginia Woolf, all the bright and disinterested amateurs of evening parties and port-side cafés, all owe him something. So, while that magnificent and loquacious eclectic Courbet was ranting Realism and painting Hals-Riberas, here was the authentic and unknown realist, accepting life as it passed and fixing in definite, permanent forms his glimpse of the unfixable.[1]

Guys and Manet bring us right amongst the Impressionists ; before writing of them I should like once again to remind you that, whereas up to 1815 to paint according to

[1] I take this opportunity of saying once again that I hope it is excusable to quote from one of my own books, published four years ago, when I can think of nothing better than what I then said to express what I would be saying now.

doctrine in a prescribed manner had been the normal practice of painters great as well as small, since that date the so-called schools of painting had been no more than spatterings caused by the jump of one tremendous fish. Romanticism was Delacroix with an ambiance of bubbles ; Classicism, after the departure of David, Ingres and—a little to change the metaphor—a fry of pompiers ; Barbizon was Rousseau (no great catch), for Millet never accepted in their entirety the laws of the forest ; and Realism was Courbet. Impressionism, as we shall see, was different. The nineteenth century, as I may have said once or twice too often and as I shall doubtless say again, was the age of individuals ; wherefore each new master was superficially unlike, not some master who had died a hundred years before, but his immediate predecessor. Only by bearing this fact in mind, and that other fact, that even cultivated people cannot recognise a new work of art unless it is like something with which they are already familiar, can we account for the now obvious perversity of nineteenth century taste.

Inevitably the new pictures that were generally admired were those of the sedulous apes, of the little followers who were content to go on imitating—for when there is no tradition imitation does duty for scholarship and science—the last new master but one. The leap from one master to the next came too soon and looked too broad for the ordinary amateur. And yet, as I was saying a little while ago, when one sees hanging in a single room pictures by Watteau, Fragonard, Courbet, Renoir, Cézanne, and Matisse, one is astonished to find how much they have in common. It is not the difference between the *fêtes-galantes* school and the late eighteenth century, between Realist, Impressionist and post-Impressionist that takes the eye, but the similarity : one notices that they are all good and all French.

Now the Impressionist or pleinairiste movement was more like what we mean by " a school " when we are talking about painting before 1815 than anything which since that date had gone by the name : indeed, it is the only school proper of the nineteenth century. It got the title by which it is

known and coherence of a sort in 1874, at which time it numbered amongst its adherents no fewer than eight painters of the first order. Of these only three—Monet (1840–1926), Pissarro (1830–1903), and Sisley (1839–1899)—painted and continued to paint all their lives, more or less, according to a professed doctrine and recognised rules. Renoir (1841–1919) and Cézanne (1839–1906), the greatest of those who were called Impressionists, though genuinely of the school, were less consistent. Renoir painted very few strictly doctrinaire pictures, and Cézanne, who in later life outgrew the theory and denounced it, perhaps not one. On the other hand, Manet for a time experimented diligently and with profit in the new technique, and so did his deliciously gifted sister-in-law, Berthe Morisot (1841–1895). Degas, who was always reckoned of the school and sent pictures to its exhibitions, was never a pleinairiste.

It is convenient to divide the Impressionist school into two groups—the pictural and the graphic : the nomenclature is vague, but it has its meaning and may have its use.

The doctrine, to which at one time or another all the pictural Impressionists adhered, was derived in part from Courbet, in part from Constable, and in part, after the two theorists of the movement, Monet and Pissarro, had in 1871 visited the National Gallery, from Turner : and then, above all, there was science. It was Turner's last pictures which seem to have confirmed by demonstration a doctrine hitherto theoretic. "Monet a raconté comment, durant un voyage à Londres avec Pissarro, il eut devant Turner la sensation d'une éblouissante confirmation de ce qu'il cherchait," writes M. Camille Mauclair (*Claude Monet*, p. 28). This homage to Turner is, I know not why, peculiarly distressing to the Eurasian writers who have made themselves responsible for the defence and illustration of French painting. But distressing or no it can hardly be gainsaid, since it cannot be denied that M. Mauclair knows far more about what Monet and Pissarro thought and said than is known to the minor prophets of Montparnasse. The Impressionists worshipped also as ancestors Constable, Delacroix,

Fragonard, Gainsborough, Watteau, Rubens, and the Venetians. Manet, of course, owed an immense deal to Velasquez in particular and the Spaniards in general ; to Hals also. And then, as I have said, there was science. Certainly the pleinairistes attached the greatest importance to the latest theories about light, only I am credibly informed they completely misunderstood them. To Corot, the grandfather of the movement, their attitude was affectionately contemptuous, though between '55 and '65, before the new theory was elaborated or group-consciousness had set in, Pissarro had styled himself " élève de Corot " : on the other hand, the admirable and independent Boudin (1824–1898) they seem at times to have considered one of themselves, and they respected as a forebear Monticelli of Marseille (1824–1886), whom I fancy they were inclined to overrate.

On principle the pleinairistes, the pictural Impressionists, painted only what they saw. What did they see ? Light, said the men of science : our visual experience consists of sensations caused by light ; colour merges

into colour ; bounding lines, like perspec-
tive, are mere intellectual makeshifts. Then
let us be true to our sensations, said they,
let us render light. And how ? By means
of the scientific palette, division of tones
(those famous " petites touches ") and the
correct use of complementary colours.
Above all, there is to be no rendering of
nature at two removes, no making of sketches
in the open and working them up afterwards
in the arranged light of the studio. We
are open-air painters—pleinairistes—who sit
down before the motif and render our
sensations direct.

Now this theory is, of course, neither
better nor worse than another. It served
its turn, and that is as much as can be asked
of any artistic theory. It gave young
painters something to get excited about,
and it gave them the support of an intel-
lectual conviction—a conviction based on
science and logic—when what they produced
appeared nonsensical to the profane. (Be
it noted that as they grew older and surer
of themselves they depended on it less.)
But the greatness of the Impressionist school,

which if you include under one label, as most people do, the pictural, the graphic and the self-styled " neo " Impressionists, is the richest in the history of French painting, has little to do with the technical theories professed, and even less with the general doctrine to which allegiance was sworn. The greatness of Impressionism has to do with the genius and talent of about a dozen men and one woman.

Let us take the pictural Impressionists first. To their side of the movement may be, and generally are, ascribed five great painters—Manet, Monet, Pissarro, Sisley, Berthe Morisot, and two masters—Renoir and Cézanne. It seems ludicrous not to say a word about the particular achievements of each, but to say a word only seems more ludicrous still. Yet more I could not say, for already I have exceeded my limit ; and there remains to be said about Impressionism in general, and especially about its later developments, something which is likely to be of more use to readers than any little paean I might send up in praise of these adorable masters. For, after all, who needs

PLATE XXIX

Renoir                              Baigneuse

nudgings or exclamations of mine to enable him or her to enjoy the most accessible and seductive masterpieces in the whole range of European painting ? Of Cézanne, to be sure, I must speak presently, when I come to deal with developments ; of Renoir I will say only that he is one of the greatest of French painters, and in my opinion one of the great painters of the world.

What I call graphic Impressionism owes something to Manet and a little to Courbet ; but what it inherits from the latter comes rather through what he said, from his choice of subjects and attitude to life and art, than from what he did. Guys, as I have tried to show, was an influence both technically and intellectually—an influence, I mean, by reason both of his style and of his point of view. But Ingres, not Delacroix, is the real master of Degas ; and Degas (1834–1917) is the most masterly of the graphic Impressionists. With him comes into the movement and into European art a new and pervasive influence—the influence of Japan. Intellectually Degas was intensely modern ; at the same time he was a classic

with Ingres for idol : Japanese prints, with their admirable purity of line, nowise offended his classicism, and satisfied his taste for modernity. From them he learnt those disquieting tricks of composition, of looking at things from odd angles, from right above or just below ; and from the East rather than from Science came that frank vision which accepted facts so simply that the muzzle of a bassoon or an opera hat can become quite naturally the foremost object in a composition. The unexpectedness of Degas's designs has been attributed to the study of instantaneous photographs. Possibly some were suggested by photographs, but it was Japanese prints that gave him the idea of turning photographs into aesthetically effective patterns. A passion for truth, shared by the best of his generation—painters, writers, and men of science alike—impelled him to try to see things as they were and not as painters were expected to see them ; instead, however, of seeing the world as the pleinairistes saw it, as a congeries of multi-coloured masses melting into each other, Degas and his followers,

*Vizzavona photo.*

Les Courses

Degas

prompted by the Japanese, were apt to see it, not less truthfully, as a pattern—a pattern sometimes almost flat. This scientific taste for facts and this modern taste for the oddity of facts—for facts by convention decreed unsuitable to art, ungainly gestures for example—were, in the case of Degas, matched by a prodigious gift for seizing and fixing them. To this extent his was a snap-shooter's art. And on this account he and his group may fairly be called, as called they were, Naturalists. Did they not make a point of accepting movements as they came, natural, unposed? For like reasons the pleinairistes also acquired the name, since they too set themselves down before any motif that came their way—a haystack, an omnibus, any bit of external reality at that time considered unpaintable—and strove truthfully and without additions to render their sense of it. Further, this blessed word " Naturalism " had the advantage of includ-ing, or seeming to include, under one con-spicuous label, not only the two groups of painters, but certain writers—Maupassant, Zola, Edmond de Goncourt—who during

the last quarter of the century appeared to be trying to realise in words similarly unconventional experiences.

Again I must apologise. Having squeezed in a word about Degas, I have left room to say about his brilliant disciple Toulouse-Lautrec (" Ce que Degas a fait de mieux c'est Lautrec," laughed the reckless young lions of the " nineties ") only that he was born in 1864, died in 1901, and at his best is something better than brilliant. On the other hand, for saying even less about Forain, Raffaëlli, Wilette, Steinlen and Cheret I make no excuse : to their own generation they seemed exciting ; to ours they seem amusing and typical, and to the future they are unlikely to seem more.

Before hurrying on to the last stages of Impressionism, to the solvent influence of Cézanne, to Gauguin and Van Gogh (sometimes called " neo-Impressionists," sometimes " Symbolists," and both in a sense anti-Impressionist),[1] and to Seurat the grand neo-Impressionist, with whom, I take it,

[1] For further light on the relation of these artists to Impressionism, see *Landmarks in Nineteenth Century Painting*, last chapter ; or, better, Maurice Denis's *Théories*.

Impressionism ends and post-Impressionism begins, there is just one quality of Impressionist art—a quality of which I have written at length elsewhere—about which I would like to say something here because of its effect not on painters only, but on the general sensibility of the late nineteenth and early twentieth century. Impressionist art is essentially pagan. Paganism, as I understand it, is the acceptance of life as an end in itself. To give point to life, feels the pagan, one need not make oneself believe that it is a means to something else—to a better in another place, to a juster organisation of society, to complete self-development. Life is not a brief span in which to do something for one's own soul or for one's fellows, or for that future which makes so many and such exorbitant claims on the present, but something to be enjoyed. The pagan, in fact, accepts the world—his world—as he finds it, and makes the most of what he finds. Now I do not doubt that the great Impressionist painters were pagan by temperament; but what I want you to observe is that they should have been so on principle. According

to the Impressionist doctrine one can find in one's surroundings wherewith to fill to the brim a work of art, *a fortiori* a human life. Observe how this theory impels towards paganism, and if you happen to be a psychologist pause by all means to draw an inference concerning the relations of men to their creeds. The Impressionist painter was bidden by doctrine, and therefore presumably by temperament, to take his canvas and colours out of doors and there begin and end his work. In search of motifs out he took them ; he took them wherever he went, into the streets and into the country, down the river and into the café, into the railway station, on to the race-course, into guinguettes, gargotes, and four-wheeled cabs. In such motifs he was to find enough to fill a work of art to the brim ; he might put nothing into his picture to help it out, no tragedy, no comedy, no pathos, no incident ; he had to find the stuff of art, and all of it, in what he saw ; so if he were not something of a pagan it looked like going hard with him. And what quality is there in guinguettes and gargotes, in railway stations

and omnibuses, in the appearance of contemporary life and the vision of the passing show, that will suffice to fill a work of art? There is beauty. It sounds simple; but in 1880, even with the hint from Guys, one had to peer long and passionately to find it. Now that the Impressionists have made the revelation we can all see for ourselves the beauty of things as they are. But remind yourself that for fifty years it had been taken for granted that whereas stage-coaches and sailing-ships, classical antiquity and medieval costume were beautiful, omnibuses, railway trains, factory chimneys, top-hats and frock-coats were hideous, and you will realise that this rediscovery of paganism was an event in the history of European sensibility.

The Impressionists discovered the beauty of the modern scene, and, bettering their instructions, added a lyrical quality—their delight in it. They were enchanted by that world, the world as they found it, which they had been sent to woo by the austere canons of a scientific creed. The marriage of reason turned into a love affair. To the passing show they had been bidden look for

all they required : the passing show was lavish beyond hope or imagination. No wonder they fell in love ; and no wonder, given their genius for expression, they made the sensitive of their age and the next share the emotion.

Within its limits, Impressionist performance, at its best, seems to me above censure if not beyond criticism ; but Impressionist theory was bound to provoke a reaction. That theory, besides being absurd in itself, produced in the hands of little men a welter of confusion and incoherence. Theoretically the Impressionist painter was to accept uncritically what his eyes brought him, he was forbidden to use his mind ; he must not impose a design and arrange his sensations according to plan, for that was to be intellectual, to play tricks with nature. I need not say that all the great Impressionists did impose a design ; but it was the artist lurking in the subconsciousness of the conscientious painter that did it. The lesser men, with little or nothing of the artist conscious or unconscious about them, were all capable of producing, and did—some

more, some less—produce pictures that were
shamelessly unorganised, disorderly and
stupid. Against this anarchy Cézanne was
the first to react ; and Seurat (1859–1891),
who called himself a neo-Impressionist,
formulated the doctrine of reaction : this
neo-Impressionist was, as we shall see, in
fact a neo-Classicist. Between Cézanne
and Seurat stand Gauguin (1848–1903) and
Vincent Van Gogh (1853–1890). Gauguin,
a considerable painter but of a class alto-
gether below the masters, provoked, partly
because the nature of his revolt against
Impressionism was easily understood, partly
because he combined the dashing air of a
rebel with the exotic of a pirate, a vast stir
amongst the young. He was adored this
side idolatry—and beyond—before the subtle
Cézanne or the profound Seurat were so
much as respected. Vincent Van Gogh,
a mad Dutchman of genius, who has left
us pictures of blinding beauty and banks of
rubbish besides, also called himself a neo-
Impressionist, and deserved the name in
that during the last and only effective years
of his life he was drawing all the sustenance

he required from Impressionist paintings. At the same time he manifested a dog-like devotion to Gauguin, and professed admiration for Cézanne. These four, taken together, may be seen as the last chapter of Impressionism or the first of a new Classicism. They are certainly the cornerstones of a new movement which, under the non-committal name of post-Impressionism, was to dominate the first years of the new century.

Of Cézanne's pictures surely I have written enough in season and out and in divers places. So suffer your guide to step forward and observe that his colour, which is always marvellously subtle and lively, sometimes attains a gem-like beauty—such expressions are permitted to guides, especially when they happen to be exact—which one might believe went beyond the possibilities of paint, were there not generally a Renoir round the corner to recall one to order. Anyone who cares to go to the Tate Gallery and, after studying the Aix landscape by Cézanne, look at the right-hand lower part of Renoir's *Parapluies*, will see in

*PLATE XXXI*

Cézanne
Paysage

a moment what I mean, says the guide. Further, he thinks it his duty to point out that Cézanne's palette was not the scientific palette of devout Impressionism ; and that, for all his admiration of Delacroix and Courbet, his pictures make one think of Chardin and Poussin. May I here step forward to add that, as for his doctrine, if doctrine it can be called, it would be of no consequence were it not that for a dozen years or so painters regarded not only what he had done, but all that he had said, as a source of inspiration ? What it amounted to, this famous doctrine, must be deduced from those two notorious sayings : " Je veux faire de l'Impressionnisme quelque chose de solide et de durable comme l'art des Musées," and " Il faut se méfier des Impressionnistes : tout de même, ils voient juste."

The performance of Cézanne combines with the profession of Seurat to compose one of those familiar points in history which are at once full stop and capital, the end of one sentence and the beginning of another. To anyone writing an essay on French painting

in the year 1931 Seurat is the indicated terminal. He died thirty-five years before the last of the great Impressionists ; but a picture of his was the latest to be hung in the Louvre,[1] and his doctrine implies the end of Naturalism and announces the gospel of construction. Seurat is eminent as one of the greatest painters of the great age ; he is singular as a thorough-going theorist who succeeded in producing masterpieces according to plan : he is original and forward-looking. Of his curious and by no means negligible ideas something must be said because, indirectly, they have had a considerable effect on twentieth century painting ; but for a fuller and fairer exposition I must once again refer the reader to my book. His notion appears to have been— for he never made his ideas quite clear, and his biographer, Madame Cousturier, has made them no clearer—that many people are born with things of importance to say who must remain for ever dumb and dissatisfied for want of the technical skill to say

[1] *Le Cirque* : it has since been moved, but temporarily, I understand.

them. To express oneself in paint, he thought, was made unnecessarily difficult by the fact that the would-be plastic artist is obliged, not only to have something of his own to express, but to hammer out a means of expressing it. Seurat wished to devise a completely impersonal method of expression, appropriate to an age of equality to which he sincerely and generously looked forward, a method which could be learnt as one learns to play the typewriter. He set himself therefore to provide for the citizens of an approaching social democracy a series of scientifically coloured and graded discs, and a small collection of geometrical forms. In these the maladroit but inspired artist of the future would find the synthetic equivalents of the forms and colours of nature. Needless to say, when the first grand anti-individualistic picture had been constructed out of antiseptic wafers and standardised parts it was as personal as if it had been painted in those bourgeoise "petites touches" of Monet, or the aristocratic thrusts and slashes of Rubens. It was a Seurat.

But if by taking thought Seurat did not

succeed in creating an impersonal means of expression, he did succeed in undermining Impressionism. In his philanthropic endeavour to provide the ungifted self-expressionist of the future with a manageable bag of tricks, he not only produced a few magnificent works of art, but provided the gifted young of the rising generation with a new ideal and a new set of ideas. In order to reduce the higgledy-piggledy forms of the Impressionists to their elements he had found himself obliged to analyse—to reduce natural forms to their component parts, and to synthetise—from the component parts to build up abstract forms. He had provided himself with shapes and colours that could be handled methodically, that is intellectually : for a moment no one seemed to remember that this had been done before. It had been done by all the great Classical painters : thus had Poussin, thus had Ingres handled forms and colours. When this was noticed the shock, as you may suppose, was considerable. What ! this man who called himself a neo-Impressionist was harking back to Classicism and neo-Classicism, the bugbears of all good

Naturalists. Painters and amateurs, who had taken it for granted that they were being led by this earnest seeker after scientific truth, with his commendable interest in the division of tones, towards a familiar resting-place, suddenly found themselves on their way to the antipodes : in fact, they were on their way to Picasso. It is what will happen when people begin pushing their theories to logical conclusions : it is what saves the human race from becoming utterly despicable. An idea honestly followed may lead anywhere ; and thus it came about that the bewildered " nineties " were confronted with the almost forgotten classical doctrine of simplification. In Paris, before the turn of the century we begin to hear talk of cubes and spheres, of schematic forms and hieratic movement, of planes and directions, of Poussin and Ingres—above all, of construction and architecture ; while far away, at Aix-en-Provence, an eccentric old gentleman is muttering anxiously " cônes," " cylindres," and looking at reproductions of Greco. For, while Seurat with vast expense of intellect was analysing and synthetising for the good

of an unborn race of Sunday-painters,
Cézanne, neither intellectually nor bene-
volently, but under some odd compulsion
of genius, was worrying about making of
Impressionism " quelque chose de solide et
de durable comme l'art des Musées."

Seurat added to the stateliness of his
design, obtained by rigorous simplification,
an astounding intensity obtained by sacrifice
also. Few painters can have felt more, and
perhaps none has compressed his feelings so
much. He wrung every inch of his picture
dry, and each twist meant the extrusion of
some delicious overtone. You can find
them, those overtones, in some of his early
sketches which still wear the enchanting
smile of Impressionist landscapes ; but they
had to go, and in the end each loss was com-
pensated by added intensity. No wonder
these pictures disconcert at first sight, and
that it is only at second or third that the
incredulous feel ready to exclaim, as I heard
a visitor to the Lefèvre gallery exclaim :
" Why, these things are more real than
reality." He was not looking at one of the
grand hieratic compositions, such as *La*

PLATE XXXII

Seurat

Paysage

*Grande Jatte*, but at a rendering of sand and water at Grandchamp or Honfleur, and what he meant was that the picture made him see more subtly and therefore feel more profoundly. It was one of those remorseless studies out of which all obvious charm of sea and shore has been squeezed, but which in exchange offer subtleties of tone or rather of relations of tones hitherto unrecorded and probably unperceived. Only by ruthless elimination of those bewitching melodies with which the Impressionists ravished and still ravish our eyes could Seurat[1] succeed in revealing these subtler relations, in touching harmonies—I will not say more moving— but rarer, more acute.

One last repetitious word about this nineteenth century, which is the most splendid in the history of French painting, the strangest, and the most completely French. The splendour, abundance, and variety of its masterpieces are, of course, its recommendation ;

[1] I had meant to reproduce another and more instructive picture also in Mr. Courtauld's collection—a superb example of Seurat at his most austere. The owner assured me that all the quality of this masterpiece would be lost in a photograph. I did not believe him, but experiment proved that he was perfectly right.

its peculiarity lies in the insignificance of schools and the importance of persons. It is the age of individuals. Why? "Luck," you say, " a shower of stars : genius happens." I do not believe it ; and if I did, I should still have to inquire how, with that air of flouting the tradition and insulting the public, these extremely unpopular individuals yet managed to survive. It seems to me they survived because the nineteenth century was rich and democratic. Never before had there been so much money, never before had money been so widely distributed. Of the five thousand in fifty millions capable of appreciating, at its first appearance, an unconventional and therefore upsetting work of visual art, as many perhaps as fifty were in a position to buy. That had never happened before : on any given day in any previous century it is unlikely you would have found as many as five. Five were not enough, fifty were. And it was just these fifty who, by keeping alive young painters of originality, by buying pictures at first sight shocking to conservative patrons, made possible the

existence of an individualistic art. So long as the State, the Church, and a few aristocrats and rich merchants were the sole patrons nothing of that sort could have happened : for to please the ordinary cultivated patron a work of art must not differ too much from things to which the patron has become accustomed, it is essential that the artist shall not appear to be in perpetual contradiction with his elder brother. Only the extraordinary patron can see that the artist only appears to be in contradiction, and not till the nineteenth century did the extraordinary patrons make their influence felt. Then half a dozen of them—a doctor, a lawyer, two writers, a hotel-keeper and a civilised loafer on seven hundred a year—sufficed to keep going some greatly gifted young man of innovating temper and unconciliatory manners —precisely the sort of young man that Church and State, aristocrats and merchant princes dislike.

That is how most of the great painters of the nineteenth century were enabled to survive their early and inevitable unpopularity ; they were kept by a minute fraction

of a new class of amateurs called into existence, into purchasing power at least, by the new political and economic system. The industrial revolution which created enormous wealth, and the political which distributed it, made possible an individualistic art. The fertilisers of this marvellous efflorescence of particular genius were two things of which one or the other is nowadays anathema to all serious and civic-minded persons, while to many both are abhorrent : let us face it, the foundations of nineteenth century painting were industrialism and democracy.

To conclude an essay neatly one should devote the last paragraph, first to restating one's earliest generalisation, then to asserting proudly and if possible with a catch in the voice that one has proved it up to the hilt. What I said at the beginning—and I realise now that it was a reckless thing to say —was that French painting is humane, tactful and conscious of its limitations, that without becoming pedestrian it keeps in touch with earth, that it rarely screams or takes too large a mouthful, and that through thick and thin French painters have kept

their eye on the object, bearing in mind that they were painters : all this I have not proved but I believe it to be true, roughly. At least, having surveyed the history of French painting as honestly as need be, I find no period of which it is manifestly false—except the Davidian (Fontainebleau, which was not French, does not count). But David is an exception there is no getting round or over. The best I can do about it is to point out that Ingres, on whom the mantle is generally allowed to have fallen, differed from his master admittedly in this, that he was less abstract and less declamatory, that his sense of the model was more intimate, and that he piqued himself on a power of characterisation which to his own age was so apparent that by the straiter sect (by the young Amaury-Duval, for instance) he was called a "realist." That seems satisfactory so far as it goes ; it reduces the grand exception to something encouragingly small. Ingres withdrawn, Davidism becomes a sport and a short-lived one at that. And now for those other giants of the nineteenth century—since manifestly it is to the age of

individualism and apparent contradiction that you will look for bombs wherewith to blow up my hypothesis—what shall I say about them ? Only this : which of those famous rebels, Géricault, Delacroix, Courbet, Manet, Renoir, Degas, Cézanne, Seurat, which of these intensely personal painters, these violent individuals, which—with the possible exception of Seurat who has something in common with the abstract and inhuman David—which dances outside the French ring ? To end on a rhetorical question is no bad plan either. " Which ? " I repeat, and consider my case proved.

# INDEX

# INDEX

# INDEX

# FRENCH PAINTING

*Printed in Great Britain at* THE BALLANTYNE PRESS
SPOTTISWOODE, BALLANTYNE & CO. LTD.
*Colchester, London & Eton*